LEGENDARY

—————— OF ——————

DAYTONA BEACH

FLORIDA

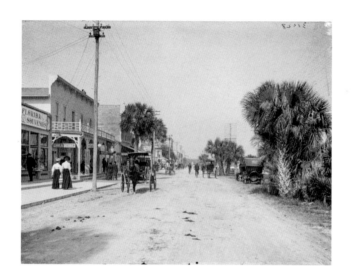

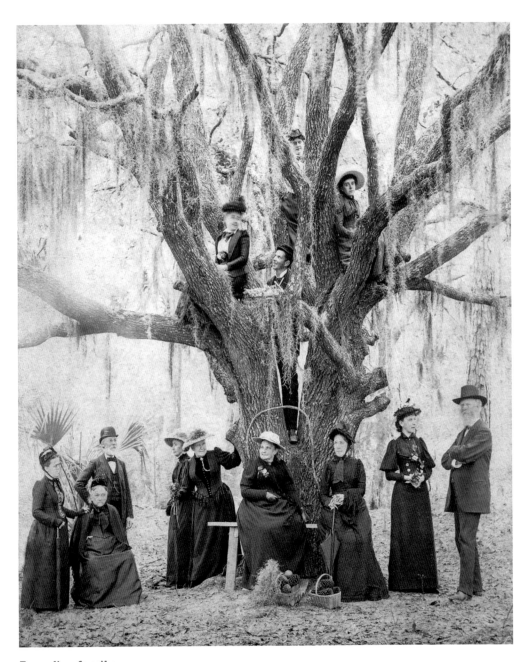

Founding family
The Day family poses for a group photograph during an 1890 outing in Ormond Beach. Matthias Day is on the far right. His wife, Mary, is seated on the bench. (Courtesy of Halifax Historical Museum.)

Page 1: Downtown
A bustling Beach Street is shown in this glass-negative photograph taken about 1910, within two generations of the town's founding. Note the souvenir store on the left. (Courtesy of the Library of Congress.)

LEGENDARY LOCALS

OF

DAYTONA BEACH

FLORIDA

MARK LANE

To Gerry

Thanks for putting up with Watson in 1st grade

Mark Lane
2015

LEGENDARY LOCALS

Legendary Locals is an imprint of Arcadia Publishing
Charleston, South Carolina

Printed in the United States of America

Library of Congress Control Number: 2015937645

For all general information, please contact Arcadia Publishing:
Telephone 843-853-2070
Fax 843-853-0044
E-mail sales@arcadiapublishing.com
For customer service and orders:
Toll-Free 1-888-313-2665

Visit us on the Internet at www.arcadiapublishing.com

Dedication
For John and June Lane, who brought me here.

On the Front Cover: Clockwise from top left:
Yvonne Scarlett-Golden, the city's first black mayor (courtesy of the *Daytona Beach News-Journal*; see page 119), a campaign banner for David Sholtz (courtesy of the State Archives of Florida; see page 31), Flora Alma Mae Kitchell (courtesy of Halifax Historical Museum; see page 15), Mary McLeod Bethune in her college office, 1943 (courtesy of the Library of Congress; see page 33); former mayor Larry Kelly congratulates incoming mayor Bud Asher, election night 1989 (courtesy of the *Daytona Beach News-Journal*; see page 89), L.D. Huston, Daytona's first mayor (courtesy of Halifax Historical Museum; see page 13), rumrunner William McCoy (courtesy of Mariners' Museum and Park, Newport News, Virginia; see page 37), the beach behind the Clarendon Hotel, 1911 (courtesy of the Library of Congress), "World's Most Famous Beach" car with bathing beauties, 1930s (courtesy of Halifax Historical Museum; see page 8)

On the Back Cover: From left to right:
Beach racing on the sands of Daytona Beach in the 1950s (courtesy of the *Daytona Beach News-Journal*); racer, car designer, and promoter Sig Haugdahl at his garage about 1930 (courtesy of the State Archives of Florida; see page 43)

CONTENTS

ACKNOWLEDGMENTS

This book could not have happened without the *Daytona Beach News-Journal*'s commitment to telling the story of the Daytona Beach area, especially editor Pat Rice, who encouraged the project from its start. In the process of writing this book, I digitized dozens of photographs that were previously hidden away in the file cabinets of the newspaper's library. Newspaper libraries are called morgues in the dark vocabulary of the business, but their contents make local history come alive. I appreciate the *Daytona Beach News-Journal*'s permission to use its images and wherever possible have also credited the talented photographers who have worked there.

Thanks are also due to Halifax Historical Museum, 252 South Beach Street, which is the source of many of these photographs. Its director Fayn LeVeille was enthusiastic about bringing some of the visual treasures in the museum's archives to new audiences through this book. Her efforts made this possible.

Thanks also to the State Archives of Florida for permission to use images from their matchless photographic collection. Also, thanks go to the Mariners' Museum and Park in Newport News, Virginia, Procter and Gamble, and the Library of Congress.

I would also like to thank my wife, Cindi Lane, for her advice, editing, and support, and Erin Vosgien for suggesting the project and her patience and tactful prodding in shepherding this through the publishing process.

INTRODUCTION

Tourist towns can remember their past a little better than other places, albeit at times in romanticized form. People come to a beach town and then go back and talk up their trip. They started taking photographs as soon as cameras became something you could take with you when you traveled. They bought postcards of sights that locals considered too everyday to care about. And because of that, a book like this is a little richer than something written about a more average place. There are photographs. There are travelers' descriptions. The place shows up in news stories, magazine features, and travel guides.

Travelers discovered Daytona Beach almost as soon as it set up as a town. Only 20 years after the town's incorporation, nature and travel writer Bradford Torrey wrote in *A Florida Sketch-Book*:

> The first eight days of my stay in Daytona were so delightful that I felt as if I had never before seen fine weather, even in my dreams. My east window looked across the Halifax River to the peninsula woods. Beyond them was the ocean . . . All in all, there are few pleasanter walks in Florida, I believe, than the beach-round at Daytona, out by one bridge and back by the other. An old hotel-keeper—a rural Yankee, if one could tell anything by his look and speech—said to me in a burst of confidence, "Yes, we've got a climate, and that's about all we have got—climate and sand." I could not entirely agree with him. For myself, I found not only fine days, but fine prospects. But there was no denying the sand.

There it all was at the start: climate, sand, and people. And the climate and sand have a way of drawing a certain kind of person. The people in these pages contributed to the character and perception of Daytona Beach. Many of them gave the place the kind of prospects that were apparent even back in the early days when Torrey arrived.

This book is not a rundown of our most important citizens or most famous people. There are glaring omissions and puzzling inclusions. Nobody now holding public office is mentioned because this is not a most influential people list. People primarily associated with nearby towns are not here, but some whose work regularly spanned the city limits are. Old scandals are revisited, as well as achievements so successful that we take them for granted: achievements such as the consolidation of the towns of Daytona, Daytona Beach, and Seabreeze into one city, the modernization of Volusia County Charter, the founding of Bethune-Cookman College, and the building of Daytona International Speedway and the coming of NASCAR.

Pictured here are people you still hear stories about, whose names you notice on street signs and buildings, whom you have read about in newspapers, who built businesses and institutions. Some are representative types; others are certainly one of a kind. They are a random sampling of the great range of people who made Daytona Beach their home. They are town builders, writers, business founders, boosters, musicians, professional people, philanthropists, famous visitors, educators, artists, athletes, and builders. They are also convicted criminals, business failures, salesmen with unbelievable pitches, and rascally politicians.

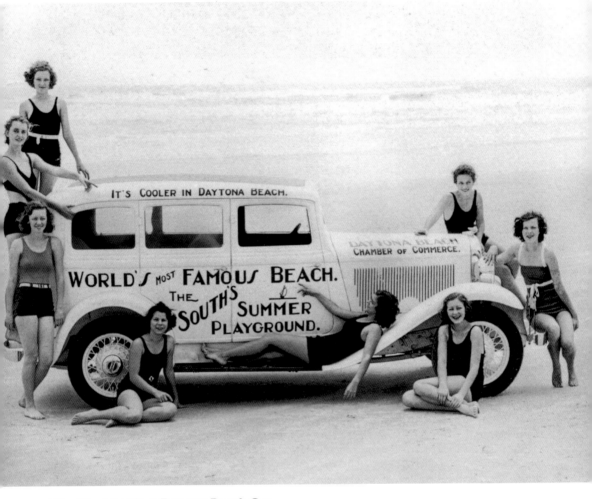

The World's Most Famous Beach Car

The slogan "The World's Most Famous Beach" was coined in the 1920s, became popular when the town got international attention because of the speed-record runs on the beach, and has stuck to this day. In this 1930s-era photograph, it is emblazoned on a car along with the town's other favorite slogan, "It's Cooler in Daytona Beach." The latter selling point began to sound like faint praise with the rise of air-conditioning and fell out of favor. (Courtesy of Halifax Historical Museum.)

CHAPTER ONE

Founding and Early Days
1870–1920

Matthias Day prided himself on seeing the big picture. And the obvious big picture around 1870 was that there were huge opportunities in a South that was still rebuilding after the Civil War. Opportunities smart operators had already mined in other states. But Florida? Here was a blank canvas, room to grow, unexploited opportunities, an inviting climate, and land so cheap one blushed to speak of it.

Day bought land on the Halifax River, 2,144 acres for $8,000 with $1,200 down. He talked up the project back home in Mansfield, Ohio, and recruited 14 people to come down and start building. Two of them brought in the machinery to set up a sawmill, and soon buildings appeared. Day had wide streets surveyed, laid out, and named. He envisioned big things.

But by 1876, Day suffered serious financial reversals, his land had been foreclosed upon, and he was back in Ohio and out of the picture in the town he founded. Still, 20 houses had already been built in this new settlement, along with a hotel, general store, and post office, and more people were still arriving.

It was enough people that they needed a local government, if only to control the aggravating number of hogs roaming the streets, which by all accounts was the biggest urban-planning issue of the day, followed closely by flooding. On July 26, 1876, at 2:00 p.m., a meeting was held at William Jackson's store and the settlers, by a 23-2 vote, decided to form a town, which they named Daytona, after Matthias Day. (Daytown and Daytonia were briefly considered and rejected.) Lorenzo Dow Huston, who chaired that meeting, was elected the town's first mayor. His son Menefee Huston, the town's first druggist, was on the town's seven-member council, along with Jackson, the store owner, and John Coslo Maley, the town's blacksmith.

The 25 people at that first town meeting came from all kinds of backgrounds. They were Confederate veterans like Menefee Huston, and Democrats and former Confederate supporters like the new mayor; they were also Northern Unionist Republicans like the Ohioans recruited by Day. At least two of those voting were black men, John Tolliver and Thaddeus Gooden, and some were immigrants like William Jackson, who originally had come from Scotland.

And from all over, new settlers and winter visitors kept arriving. This was greatly aided at the close of 1886 by the extension of the narrow-gauge St. Johns and Halifax River Railroad into Daytona. It was "the greatest event perhaps in all the history of Daytona," as *Daytona Daily News* editor T.E. Fitzgerald called it. Henry Flagler acquired the line in 1890, and it became part of the Florida East Coast Railway, connecting Daytona with the rest of the world.

According to the US census, 771 people were living in Daytona in 1890 and 1,015 in the Halifax area. In 1885, *Webb's Historical, Industrial and Biographical Florida* reported, "Daytona is the name of a thriving town of a 1,000 inhabitants on the Halifax River . . . The settlers are mostly from the North and West and all doing well."

These fulltime residents were soon joined by wealthy winter residents such as Eliphalet "Eli" Hubbell Hotchkiss, the Connecticut industrialist who manufactured the bestselling Hotchkiss stapler; James Gamble of Procter and Gamble; and Charles G. Burgoyne, the New York City commercial-printing magnate who retired here, developed the downtown area, became president of Merchants Bank, built a

community center and promenade along the river, and served a term as mayor. In nearby Ormond, John D. Rockefeller had a home across the street from the Ormond Hotel.

The transformation from settlement in the woods to a small modern town happened within 25 years. The inaugural issue of the first newspaper, the *Halifax Journal*, was published in 1883. The first ice factory opened around 1885. By 1888, two wooden bridges spanned the Halifax River. Merchants Bank of Daytona opened its doors in 1896. Telephone wire was strung up in 1900, and electric lights went on in 1901. The first high school graduating class went into the world in 1902—five girls and one boy. The first city policeman put on a uniform in 1904. In 1906, there were 296 cars licensed in Florida, and 74 were in Daytona.

A 1907 city directory said the city had 20 hotels, eight doctors, three bakeries, a Chinese laundry, four photographers, a bowling alley, and a public library, but "no saloons." A waterworks opened in 1908. A fire department formed in 1909. A baseball park was built on City Island in 1914, where baseball is still played today. The place was taking off.

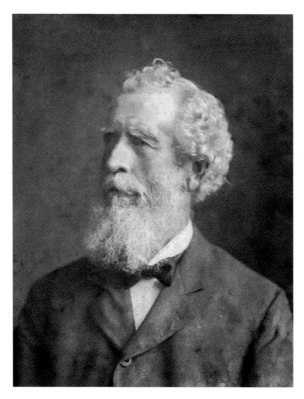

Matthias Day (1824–1904)

Matthias Day was a visionary, inventor, progressive thinker, newspaper editor, entrepreneur, salesman, teacher, and would-be city planner and developer. But he was also a man whose plans sometimes ran ahead of his capital, a man with "more charisma than cash," as one writer put it.

That is why he only briefly lived in the town that bore his name. He left the area after the land he bought to build his new city on the Halifax River was foreclosed on and resold, something that happened within 16 months of his purchase.

Born in 1824 in Mansfield, Ohio, Day was trained as a saddler but instead went to Oberlin College, from which he graduated in 1848. He became a newspaper editor, promoter of the newly founded Republican Party, and ardent foe of slavery. He aided Underground Railroad operations in Mansfield, helping to secretly move escaped slaves to freedom in Canada.

He moved to manufacturing, becoming a partner in Blymyer, Day and Co., makers of farm machinery. While looking for sales opportunities for the firm and casting about for real estate opportunities in April 1870, he met John Hawks in Jacksonville, who told him about promising land along the Halifax River and arranged to show him. "Walked back to the beach. Doubtless the finest in the U.S.," he wrote in his diary. "Where a man can have a 30-mile trot on a hard sand floor, perfectly smooth, surf and sea inspiring, refreshing and invigorating."

He arranged to buy 2,144 acres for $8,000 with $1,200 down in 1870. Most of the land had been part of a long-abandoned sugar plantation. He had it surveyed and platted. Wide boulevards were envisioned and mapped. He intended to sell the lots at $25 apiece and make a fortune in Florida real estate. He saw to the building of the Colony House, later the Palmetto House, where new settlers and sales prospects could stay.

But financial reversals and the onset of recession ended his plans, and his Florida land was sold at court auction in 1872. Still, new settlers kept coming, and during a visit in 1899, Day noted with some pride the kind of bustling place that bore his name. He died in 1904 of pneumonia. (Courtesy of Halifax Historical Museum.)

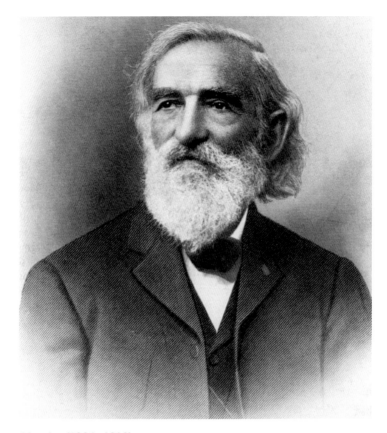

John Milton Hawks (1826–1910)

John Milton Hawks was a medical doctor, a seller of patent medicine (he favored a concoction of lobelia seeds, bitters, and rum), a fervent abolitionist, an early advocate for women's suffrage, and a founder of Port Orange (which he named) as well as Hawks Landing (later absorbed into Edgewater). And he helped found Daytona by selling Matthias Day on the idea of starting a settlement along the Halifax River. He had met Day in Jacksonville in 1870 and arranged a trip to the area, the land that would grow into the town bearing Day's name.

It is easy to think that Day found a kindred spirit in Hawks: both were radical Republicans, prewar abolitionists, men who prided themselves on being visionaries, and enthusiastic about the just-around-the-corner prospects of East Florida. Hawks had served as a surgeon for the 33rd and 21st regiments, US Colored Troops, and after the war hit on the idea of resettling former slaves in Florida, where they could farm and harvest timber. He founded the Florida Land and Lumber Company and created a freedman settlement in Port Orange.

"I wish I could feel that he is the man to manage the complicated machinery of such a concern as he imagines himself to be," his wife presciently confided to her dairy. The undertaking was a disaster, and the courts ordered the company's property sold at auction by 1867. Only a handful of settlers were still there by 1869. Still, Hawks stayed in the area and was appointed the first superintendent of schools for Volusia County. He moved south to Hawks Park, which he advertised as a "New England village on the coast of south Florida." He wrote *The Florida Gazetteer* in 1871 and *The East Coast of Florida* in 1887 and sold land and cultivated orange groves.

An obituary for his wife, Esther Hill Hawks (1833–1906), also a doctor, teacher, and reformer, described him as "a great joker and story teller, mild-mannered and good natured, and would argue any questions with anyone, but not to the fighting or irritating point . . . His manners were quaintly sweet and courtly." He is buried in Edgewater. (Courtesy of the State Archives of Florida.)

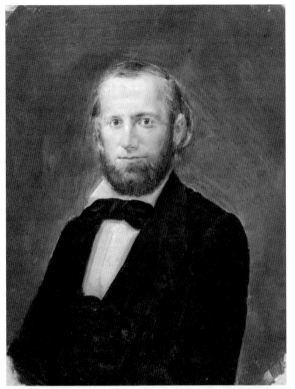

Lorenzo Dow Huston (1820–1887)

Florida is famous as a place to start over, and Daytona's first mayor, Lorenzo Dow Huston, was a good example. In 1872, he was at the center of a sex scandal in Baltimore (an ecclesiastical court acquitted the Methodist minister and educator of seducing two teenaged girls at his church), but in 1876, Huston was elected mayor of the new town of Daytona. He also became justice of the peace, county commissioner, and superintendent of public instruction for Volusia County. He was mayor for only a year, stepping down after he moved across the river. (Courtesy of Halifax Historical Museum.)

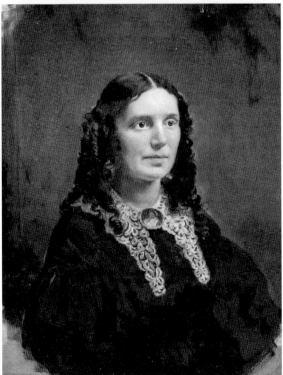

Mary Huston Hoag (1817–1895)

Mary Huston Hoag, sister of L.D. Huston, came to Daytona from Cincinnati, Ohio, in 1876 and bought and ran the Palmetto House, so-called because the shingles that had been ordered for it did not arrive, and so it was topped with a palm frond roof for a time. On South Beach Street near Loomis Avenue, it was the area's hotel and social center and often the first place a new arrival would live. (Courtesy of Halifax Historical Museum.)

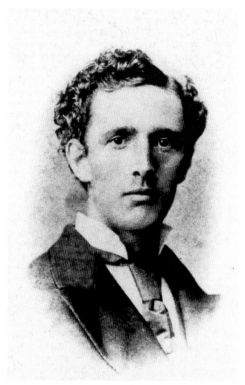

Loomis G. Day (1852–1935)
Son of Matthias Day, Loomis Day was there at the start of Daytona (Loomis Avenue is named for him) and also Ormond Beach, then New Britain. In 1876, Day delivered the votes for Rutherford Hayes—literally. Loomis heard that getting Republican ballots to Enterprise, then the county seat, would be no sure thing. So one man took a fake ballot box by the main road while Day took the real box by back roads. The decoy was snatched, but the real ballot box made it to town, and its 18 votes for Hayes were entered. (Courtesy of Halifax Historical Museum.)

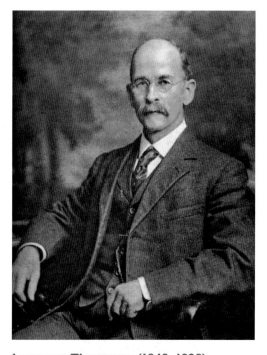

Laurence Thompson (1848–1929)
Laurence Thompson came to Daytona the year before it became a town. He ran Thompson Brothers' Store, which provided a town council meeting place, dance floor, church meeting room, and lending library. Thompson was town clerk and a councilmember. With Charles Bingham, he started Bingham and Thompson, one of the city's first real estate and insurance firms, in 1909. He built his home, now called Lilian Place, on the east bank of the Halifax River in 1884, one of the first beachside houses. Author Stephen Crane stayed there in 1897 after being shipwrecked. (Courtesy of Halifax Historical Museum.)

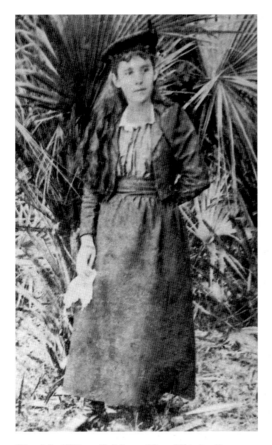

Florida "Flora" Alma Mae Kitchell (1880–1962)
The daughter of William and Amanda Kitchell, Flora Kitchell was among the first recorded births in New Britain. The family soon moved south on the beachside. (Courtesy of Halifax Historical Museum.)

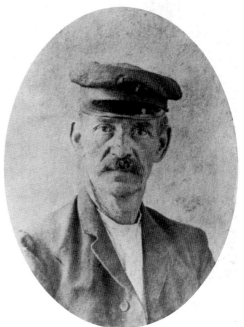

William Washington Kitchell (1849–1920)
An early settler in New Britain, William Kitchell eventually moved to the peninsula near Daytona and ran the first ferry across the Halifax River. He built boats and owned two steamboats, the *Vera* and the *Ajax*. The family home on what is now Main Street, near the riverfront, became a post office and his wife, Amanda, became postmistress. (Courtesy of the State Archives of Florida.)

William Jackson (1848–1917)
William Jackson's store, shown here, was a social and political center in the first years of Daytona. The meeting to organize the town was held there in 1876. Jackson served on the first town council as well as on the county commission and school board, and he was reputedly something a local power broker—the "King of Volusia," according to a local historian. "The leading merchant for many years, and one of the most influential men in town and county affairs is William Jackson," wrote John Hawks in 1887. (Courtesy of Halifax Historical Museum.)

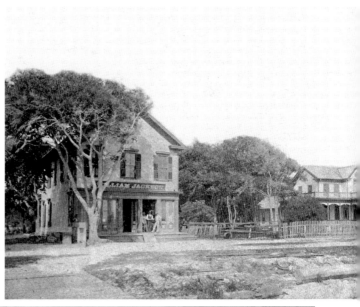

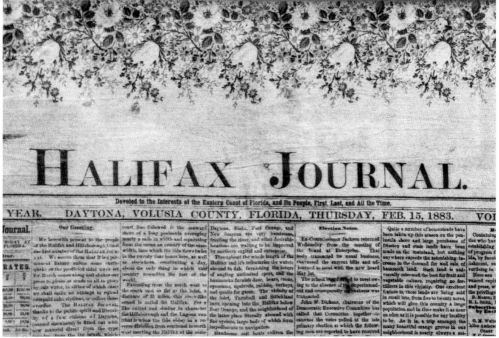

Florian Alexander Mann (1837–1924)
Florian Mann started the *Halifax Journal*, the paper that would grow into the *Daytona Beach News-Journal*. The first issue, shown here, came out on February 15, 1883, but not without some improvisation. The schooner bringing the newsprint sank, so to get the issue out, Mann bought a bolt of cotton cloth at Laurence Thompson's store as a substitute, giving it a floral border. His advertisements boasted: "The pioneer paper. The most widely circulated and universally read." Mann also wrote two somewhat fanciful and florid histories, *The Story of Ponce de Leon* (1903) and *The Story of the Huguenots* (1898). (Photograph by Mark Lane.)

Charles A. Young (1836–1919) and Sarah Cornelia Young (1842–1914)
Charles Young was a clipper ship captain, but he made his fortune running an oceanfront hotel, the Belvedere, in Asbury Park, New Jersey. During his winter visits to Daytona Beach, he was impressed by the Daytona Beach Library Club's efforts to build a library. In 1914, he donated funds to build a library in memory of his wife. S. Cornelia Young Library was erected in 1917. When a statue of Young was made for the library in 1998, no photograph of him could be found, so the sculptor fashioned an imaginary, somewhat quizzical, mariner holding a book. (Photograph by Mark Lane.)

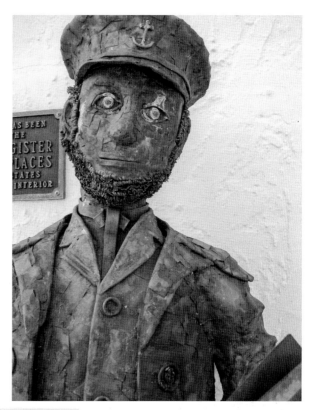

David Dunham Rogers (1850–1919)
David D. Rogers was one of the handful of settlers who arrived in Daytona before it formed itself into a town, and was elected to its first city council. A surveyor and civil engineer, he platted and named the town of Seabreeze. Rogers had the first wagon road graded across the peninsula from river to ocean in 1884 and built the second bridge across the Halifax River in 1884 at present-day Main Street. Before his death, he donated some of the land that now is part of Riverside Park in downtown. (Courtesy of Halifax Historical Museum.)

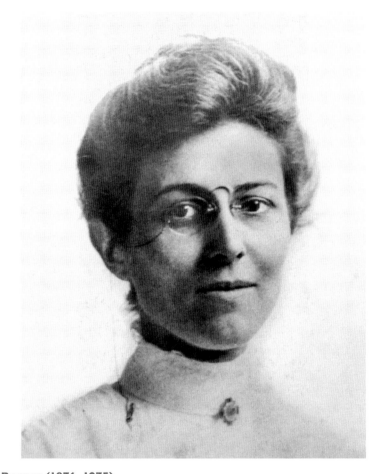

Dr. Josie Rogers (1876–1975)

Daytona had its first woman mayor in 1922, only two years after the 19th Amendment was ratified, giving women the right to vote.

Dr. Josie Rogers had been talked into running for city commission by Isabelle Chamberlain, principal at Ridgewood Elementary School, who was about to run for commission and did not want to be the only woman running for office. Responding to a dare from her friend, she ran and won as part of a reform ticket, even as Chamberlain was defeated.

When Mayor George Marks resigned to move to DeLand, Florida, and become superintendent of schools, a divided city commission voted to make Rogers mayor.

The daughter of David Dunham Rogers, she was born on November 6, 1876, only months after the town of Daytona incorporated, and was fond of saying she was "just as old as Daytona Beach."

She went to nursing school but found nursing too restrictive, so she attended and received her medical degree from Hahnemann Medical College in Chicago, a homeopathic medical school.

In 1907, she returned to Daytona and set up a general medical practice at her home at 453 North Beach Street. She was a familiar sight around town on her bicycle for years until she bought a car, a Maxwell. Interviewed by the *Daytona Beach News-Journal* after her 98th birthday, she said she particularly enjoyed treating children.

She continued her medical work until 1949, when she turned her practice over to her niece Dr. Ruth Rogers. But well into her 70s, she would still see the occasional patient by appointment. She died on April 30, 1975. The city moved her home and medical office to Riverside Park in 2003, where it stands today. (Courtesy of Halifax Historical Museum.)

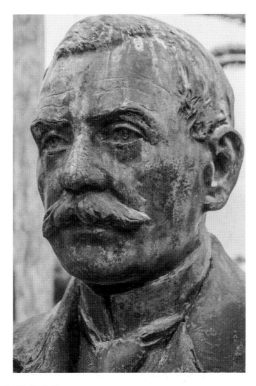

Charles Burgoyne (1847–1916)

In 1910, if any random person in Daytona were asked who the most important man in town was, their immediate answer would be Charles Grover Burgoyne.

Burgoyne was a self-made commercial printing tycoon in New York City who moved to Daytona in 1894 to relax and retire but ended up buying most of downtown. He was a one-term mayor and president of Merchants Bank of Daytona.

He had the biggest house on the beachside, which he sold so he could build the biggest house downtown. He built the town's biggest boat and put it in the town's biggest boathouse. He had a broad lighted walkway built along the river next to Beach Street that led to the town's entertainment center, the Burgoyne Casino, which he donated to the city in 1914.

The hall with its castle-like towers was Daytona's social center. It was the place to see and to be seen, especially at the free concerts by Saracina's Royal Italian Band, also underwritten by Burgoyne. (It was a casino in the sense that it was a social hall, not a gambling place.) Above its front door were the inviting words, "Come in, we've saved you a seat."

Burgoyne was 69 on March 31, 1916, when he said he was not feeling well and went home to lie down. He was dead of heart failure within an hour. The next day, the *Daytona Daily News* announced his death atop the front page in all caps, and the reporter pulled out all the stops: "Commodore Burgoyne is dead. As those words were repeated along the streets and communicated from home to home shortly after 4:30 o'clock yesterday afternoon, the city of Daytona was shocked beyond all belief, and a deep gloom settled upon all."

The newspaper reported that 6,000 people attended his memorial, a number larger than the population of the area at that time. Little is left of his legacy. His house on the beachside was torn down to build apartments, his mansion downtown was demolished in 1941, and his boathouse caught on fire in the 1950s. Even his gravesite at Pinewood Cemetery was vandalized, and the angel was broken and removed. The Burgoyne Casino burned down in 1937. But a bronze bust of Burgoyne commissioned by the city shortly after his death can still be seen in Riverside Park near Jackie Robinson Ballpark. (Photograph by Mark Lane.)

Mary Therese MacCauley Burgoyne (1862–1944)

Mary MacCauley was a teenaged proofreader at Charles G. Burgoyne's commercial printing company in New York City before she became his third wife in 1882. She is shown here in the 1890s, about the time the Burgoynes moved to Daytona Beach.

The sudden death of her husband in 1916 hit her hard. Once one of the town's preeminent hostesses and public figures, she became a recluse, retreating behind the drawn curtains of her rambling mansion on North Beach Street known as the Castle. She became a mysterious figure who figured in overheated town gossip. "Sneaking along in the dark. Hoping to catch a glimpse of the mystery lady at the window and not getting caught by her servants was a thrill," Pat Thompson Bennett wrote in her reminiscences of her Daytona Beach childhood.

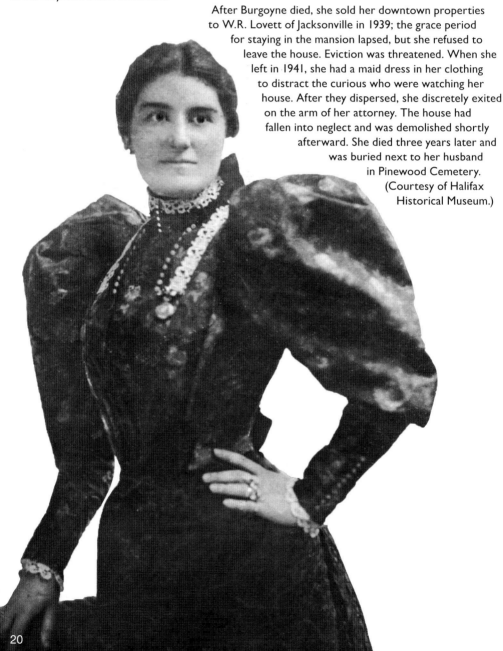

After Burgoyne died, she sold her downtown properties to W.R. Lovett of Jacksonville in 1939; the grace period for staying in the mansion lapsed, but she refused to leave the house. Eviction was threatened. When she left in 1941, she had a maid dress in her clothing to distract the curious who were watching her house. After they dispersed, she discretely exited on the arm of her attorney. The house had fallen into neglect and was demolished shortly afterward. She died three years later and was buried next to her husband in Pinewood Cemetery. (Courtesy of Halifax Historical Museum.)

Helen Wilmans Post (1831–1907)

The town of Seabreeze was built on the power of the mind's positive energies—or more accurately, the checks, money orders, and cash of people who believed in the power of the mind's positive energies. Helen Wilmans Post, a writer, publisher, New Thought movement entrepreneur, and mail-order psychic healer, fell in love with the town of Seabreeze—she always wrote it as two words, Sea Breeze. At the turn of the 20th century, she and her husband, Charles C. Post, the town's first mayor, bought land around present-day Seabreeze Boulevard and laid out the street as a wide, inviting road lined with newly planted palm trees. She and her husband sold pamphlets, books, and a weekly newspaper.

They built a hotel and store planned for a 100-acre "university of psychical research," which is why University Boulevard is called that. She planned big things for the place, and why not? The volume of mail from people seeking cures, guidance, and pamphlets from her was unbelievable. The post office on present-day Main Street had to be moved to Seabreeze to deal with it, something that created lasting ill-will from the next town over.

Postal authorities, however, felt that providing healing energies by mail was a questionable business practice and in 1901 stopped delivering mail to her business and had the couple arrested for mail fraud. The case bounced between trial and appellate courts for years. In 1905, the US Circuit Court of Appeals for Washington, DC, ruled that mental healing by mail could not be considered fraudulent on its face, and prosecutors needed to prove intent to defraud. She was convicted again in 1906.

The years in court destroyed the Posts financially and physically. They died within three months of each other in 1907. (Courtesy of Halifax Historical Museum.)

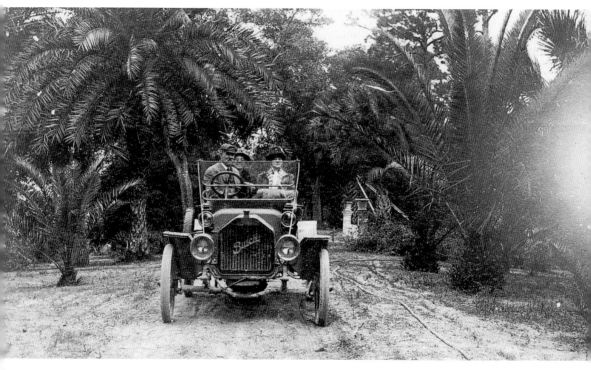

Sumner Hale Gove (1853–1926)

Sumner Hale Gove was a builder, architect, and political figure in the town of Daytona Beach before it consolidated. After a successful career as an architect and builder in New England, he moved to Daytona Beach, hoping the climate would relieve his wife's asthma, but she died in 1910. He built Daytona High School, the first Clarendon Hotel, the Rexall Drug Store, an Ormond Hotel addition, two Halifax River bridges, and many seawalls and roads. He also was a founder of the Halifax River Yacht Club. He is shown here driving with his second wife, Anna. (Courtesy of Halifax Historical Museum.)

Harrison Garfield Rhodes (1871–1929)

Harrison Garfield Rhodes was a prolific writer, playwright, novelist, travel-book writer, and magazine editor. His mother, Adelaide Robbins Rhodes, bought what had been Thompson's store in 1890, and Rhodes wintered there. He shared the house with his sister after his mother's death. Both mother and son were early trustees and supporters of Bethune-Cookman College. The school's first library building, the Harrison Rhodes Memorial Building, is named for him. In his novel *The Flight to Eden: A Florida Romance* (1907), the area is lovingly depicted as the settlement of Tomocala. (Courtesy of Halifax Historical Museum.)

Ruth Bancroft Law (1887–1970)

Ruth Law was the first woman to fly a plane in Florida, and during the winter tourist seasons of 1913–1916 she was a familiar sight on the beach in front of the Clarendon Hotel, where she took off and landed. She contracted with the hotel to take guests for rides and amuse them with exhibition flights. Law transported guests in a Wright Model B (shown here in 1914 on the beach with Law on the right and New York City socialite Elsie Whelen Goulet at left), flew acrobatics in a Curtiss Pusher, and gave flying lessons.

In 1915, the Brooklyn Dodgers held spring training on the beachside near the hotel, and somebody arranged for Law to drop a ball from the sky to be caught by manager Wilbert Robinson, who had been bragging about his ability to catch fly balls from any height. At this point, all versions of this famous baseball tale diverge. But all agree that somehow a grapefruit was substituted for a baseball and dropped from the plane. (Law later said in a letter that she simply forgot the ball and substituted a grapefruit.) Regardless, Robinson fumbled the fast-flying fruit, and it exploded on his chest, leaving him stunned and covered in pink pulp.

"My chest's split open!" He is said to have shouted. "I'm covered in blood!"

Blame naturally fell to Casey Stengel, who had already developed a reputation as a practical joker. Stengel denied this in the many versions of the story he told over his long career. (Courtesy of the State Archives of Florida.)

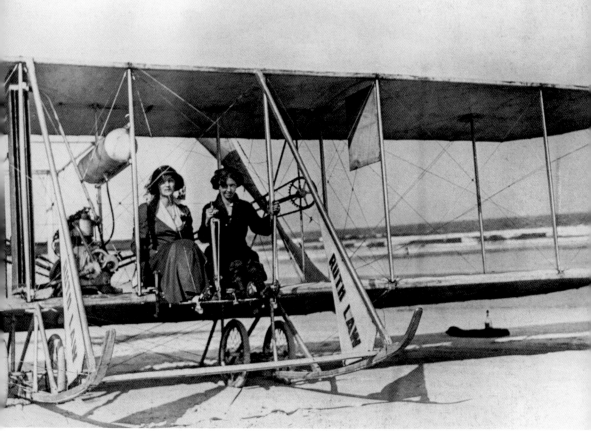

James Norris Gamble (1836–1932)
James Norris Gamble, son of James Gamble, cofounder of Procter and Gamble, was a winter resident. He had a home on the peninsula, near Lilian Place, and a lodge and orange grove in Port Orange, known as Gamble Place. He was an early supporter of Mary McLeod Bethune's work. It is said that when he first visited her school, he looked around, and asked, "Where is this school of which you wish me to be a trustee?" She replied, "In my mind and in my soul, Mr. Gamble." He was convinced. (Courtesy of the P&G Heritage Center.)

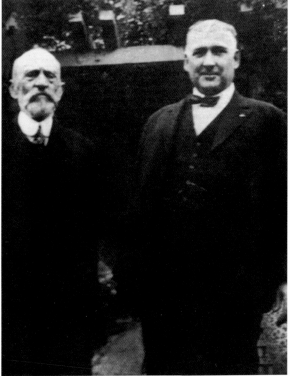

Eliphalet "Eli" Hubbell Hotchkiss (1858–1917)
Eli Hotchkiss (right), shown here with his father, George Hotchkiss, was the stapler king, the Connecticut industrialist who manufactured the Hotchkiss stapler, the world's bestselling office stapler until World War II. He bought a winter home on South Peninsula Drive that is still standing and being preserved by the Heritage Preservation Trust. He choked to death on his dinner while vacationing in South Florida in 1917. (Courtesy of Heritage Preservation Trust.)

Lilian Thompson (1873–1934)

Lilian Thompson lived most of her life in the yellow Victorian house her father, Laurence Thompson, one of the city's original settlers, built across the river from the present-day courthouse annex. The house, named Lilian Place in her honor, is now a historic house and museum. Although her education was in music (she attended the New England Conservatory of Music), she worked with father and brother in the family real estate and insurance business, Bingham & Thompson. "A capable and far-sighted businesswoman" pronounced *Gold's History of Volusia County.* (Photograph by Mark Lane.)

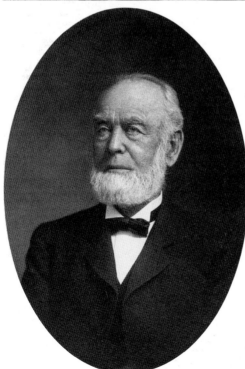

Thomas Goodall (1832–1910)

Goodall, the town on the peninsula south of Seabreeze (later called Daytona Beach), was named for Thomas Goodall, a winter resident from Maine who had made a fortune in the textile industry. The town's people were particularly grateful to Goodall because he was instrumental in seeing that the town got a post office again after losing its old one to Seabreeze in 1897. The tiny post office had been put on rollers and wheeled away. In 1902, he donated a post office building on the corner of Halifax Avenue and Main Street. It was torn down in 1950. (Courtesy of Halifax Historical Museum.)

Jonathan Garland (1835–1906) and William May Garland (1866–1948)
Pictured here is the home on First Avenue built by Jonathan Garland, an orange grower and operator of a successful stagecoach business, Garland and Matthews. The Maine native and Methodist minister came to Daytona in the 1880s. His son William May Garland, a developer and real estate magnate, moved West and became one of the shapers of Los Angeles. As president of the Olympic committee, he was instrumental in bringing the 10th Summer Olympics there in 1932, an event that city boosters saw as proof that the city had come of age. (Photograph by Mark Lane.)

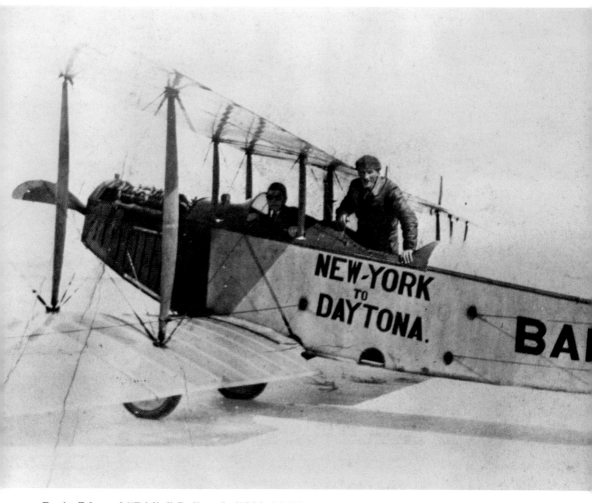

Ervin Edward "Eddie" Ballough (1892–1948)
Eddie Ballough took his first flying lessons from Ruth Law in Daytona Beach. He is shown here in a Curtiss Jenny JN-4C about to take off on the first flight from Daytona Beach to New York City in November 1919. His uncle was Charles Ballough, a developer of the town of Seabreeze and Daytona's first police chief. Ballough Road was named for the pioneer Ballough family. A former stunt pilot and air racer, he flew for Eastern Air Lines from 1930 to 1940 and logged more than a million miles as a pilot. (Courtesy of the State Archives of Florida.)

Thomas Edward "T.E" Fitzgerald (1879–1944)

T.E. Fitzgerall bought the *Daytona Gazette-News* in 1901, started the *Daytona Daily News* (later merged with the *Daytona Beach News-Journal*), and founded the weekly *Observer*. He was a publisher, successful local attorney, and writer of local history, both in his newspaper articles and his book *Volusia County Past and Present*, which he published in 1937. (Courtesy of Halifax Historical Museum.)

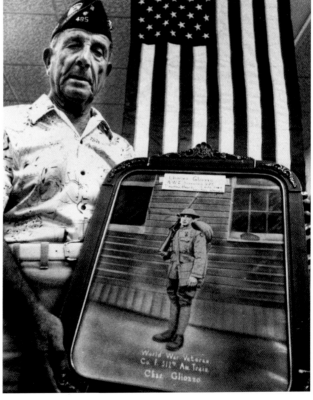

Charles Gliozzo, 1896–1998 Charles Gliozzo was one of Daytona Beach's World War I veterans. He is shown here with a photograph of himself taken during training. Daytona was a small place when the United States declared war in 1917, but the area has a surprising number of World War I veterans. At the base of a flagpole at the city's Breakers Seaside Park there are 73 names of Daytonans who fought in World War I. They include Florida governor David Sholtz, author Robert Wilder, and educator Rubert Longstreet. (Courtesy of Halifax Historical Museum.)

CHAPTER TWO

Consolidation, Boom, Bust, and Wartime

1920–1945

In the 1920s, Daytona Beach took on much of its character. It was a time of change with the merger of three cities, and the place transformed from a settlement on the river to a midsized beach town. Its visiting population shifted from a few of the wealthy who wintered here to more mass-market tourists arriving by car, and the area became world famous for automobile sports.

By 1925, the spread of development to the beachside meant that the Daytona Beach area included three towns, each contending with the other two for population, resources, and attention. There was Daytona in the older settled area on the mainland (9,592 people according to the state census of 1925); Seabreeze, on the beachside, centered on the broad street that is now Seabreeze Boulevard (population 1,792); and Daytona Beach, south of Seabreeze, previously called Goodall (population 2,129).

This was not a politically tenable situation. And various plans for uniting the city were floated as the population swelled and Halifax River cities experienced the Florida Land Boom. A consolidation plan was approved by the legislature and put to a vote on August 4, 1925. The proposal to combine Seabreeze, Daytona, and Daytona Beach into one Daytona Beach passed overwhelmingly—657 for, 167 against.

"Love Feast Aftermath of Consolidation Victory" was the headline in the *Daytona Beach Journal*, which changed its name from the *Daytona Journal* the day after the referendum passed. Between the censuses of 1920 and 1930, the population within the new city grew by an astounding 142 percent to 16,598 people.

The 1920s also saw racing's most advanced cars trying for a place in the record books on beach racing courses in Daytona Beach. Beach racing started in 1903 in Ormond Beach and soon reached to Daytona. The Daytona Beach–Ormond races, under the auspices of the Florida East Coast Automobile Association, ran until 1910. But drivers continued using the hard flat sands of Daytona Beach as the ideal surface for challenging the record books. Between 1905 and 1935, there were 15 world speed records set in the Daytona Beach area, seven of them in the 1920s, when the town, giddy at the international publicity it attracted, dubbed itself "The World's Most Famous Beach."

But the boom times could not last, and Florida experienced the Great Depression well before the 1929 stock market crash. When the real estate bubble of the 1920s started collapsing in 1926, banks around the state began failing. Merchants Bank in Daytona Beach was shuttered by the summer of 1929. That same year, the City of Daytona Beach defaulted on its bond debt, and city workers joined the swelling ranks of the unemployed.

The consolidated city government, which had begun with high hopes for reform in 1926, became increasingly corrupt. Edward H. Armstrong, the second mayor, established an effective political machine that controlled city politics until his death in 1938. In the last days of 1936, National Guard troops and

armed police faced each other at gunpoint in a city hall standoff after Gov. David Sholtz, Armstrong's longtime opponent, tried to remove him, his wife, and his allies on the city commission from office.

In 1939, the Florida legislature, citing the city's "disturbed condition by reason of political and domestic discord" dissolved the city and issued a new city charter.

Adding to the city's woes, car speeds had increased to the point where the beach was no longer wide or flat enough for assaults on the land speed record. In 1935, Sir Malcolm Campbell set the last land speed record at the beach. His next record, in September of that year, was at the Bonneville Salt Flats in Utah. The car events that had made Daytona Beach the World's Most Famous Beach had moved on for good.

This period also saw the school that Mary McLeod Bethune founded for black girls grow from the little rented wood-frame house that housed the Daytona Educational and Industrial Training School for Negro Girls to a coeducational academy with more than 300 students and eight buildings after it merged with Jacksonville-based Cookman Institute in 1923. It became Bethune-Cookman College in 1931.

The Depression-stricken city received aid through the New Deal's Works Progress Administration, which built the downtown post office in 1933 and the boardwalk, Bandshell, and clock tower projects in 1938. With the start of World War II, a US Navy air base came to the area, and a training center for the Women's Army Corps started operations in 1942, which brought some 20,000 recruits to the area, an Army Signal Corps School, and the 5,000-bed Welch Convalescent Hospital. New war-related industries sprang up, such as the Daytona Beach Boat Works, which built Navy submarine chasers and supply and rescue boats. For a time, it was the county's largest employer. The city was firmly on the rebound.

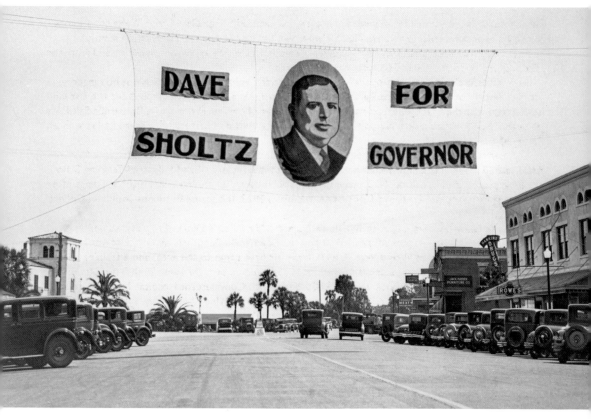

David Sholtz (1891–1953)

As of this writing, David Sholtz is the only Daytonan elected governor of Florida. In 1932, during the depths of the Great Depression, he entered a Democratic primary crowded with seven other candidates, two of whom had already been governors. He won big by promising free textbooks in public schools, better pay for teachers, and lower fees on license plates. A personable natural orator, he traveled to every county in the state, giving speeches wherever he found an audience, from a truck equipped with loudspeakers. He also took to the radio and flew to campaign events, always talking about schools, jobs, and better days ahead. Despite all political predictions, it worked. He won the runoff primary by the largest percentage up to that time. Pictured here is a Sholtz banner in downtown Daytona Beach.

These were hard times, and being an outsider worked, even though Sholtz certainly was not a typical Florida politician. Born in Brooklyn, New York, to a Jewish family (although he would become a member of St. Mary's Episcopal Church in Daytona), he went to Yale University, then Stetson University College of Law. He set up law practice in Daytona Beach and served one term in the legislature despite being at odds with the county political machine, known as the Ring. He eventually became president of the state chamber of commerce, which proved an excellent springboard to statewide office.

And as governor, Sholtz delivered. A free textbook law was passed and funded even though it was attacked in the legislature as socialistic. He established the Citrus Commission and Florida Park Service. He worked to get a comprehensive workers-compensation bill passed in 1935. When he left, the state's budget had a small surplus, and the state millage rate had been lowered.

But the governorship would be as far as he would go politically. He lost a shot at the US Senate to Claude Pepper in 1938 and afterward stuck to law and civic affairs. After a car accident in the Keys, Sholtz suffered a heart attack and died in 1953. He is buried in Daytona Memorial Gardens. (Courtesy of the Archives of Florida.)

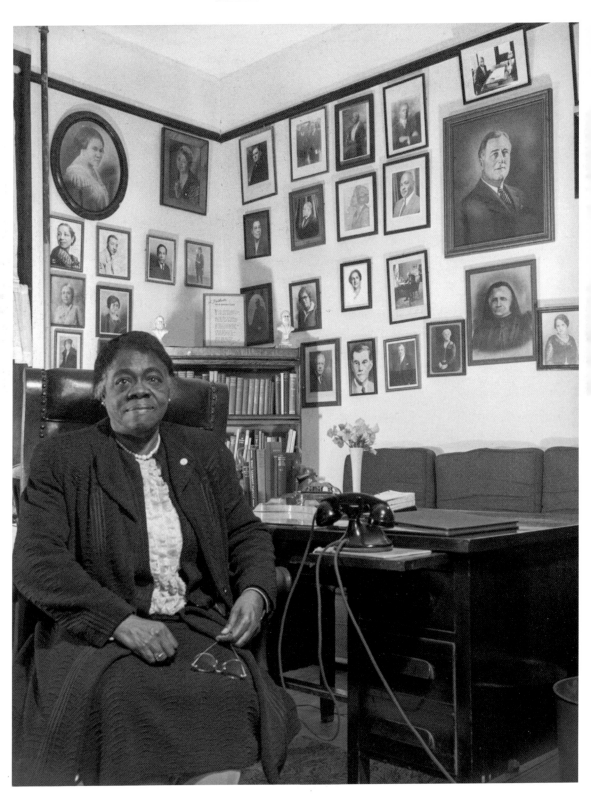

Mary McLeod Bethune (1875–1955) (ABOVE AND OPPOSITE PAGE)
Mary McLeod Bethune is shown opposite seated in her office at Bethune-Cookman College (called Bethune-Cookman University since 2007), where Gordon Parks photographed her in January 1943.

Bethune founded the university that bears her name, advised presidents, and pushed to make local politics more inclusive when Jim Crow was still the law, yet still found time to shape the lives and decisions of hundreds of individual Bethune-Cookman students. There is a statue of her on East Capitol Hill in Washington, DC, and a stamp honoring her was issued in 1985. The Mary McLeod Bethune Council House, where she worked for the National Council of Negro Women in Washington, DC, is a national historic site. Her house at 628 Dr. Mary McLeod Bethune Boulevard was designated a National Historic Landmark in 1975.

The daughter of former slaves, the 15th of 17 children, she founded the Daytona Educational and Industrial Training School for Negro Girls on October 3, 1904, "with five little girls, a dollar and a half, and faith in God," as she later wrote. It was housed in a two-story wood-frame building west of the railroad tracks, near a dump where she scavenged for school supplies. By 1931, it would become a private college with more than 300 students.

An advisor who was part of Franklin Roosevelt's "black cabinet," she was appointed director of the National Youth Administration's Division of Negro Affairs in 1933. She also served as special assistant to the secretary of war and assistant director of the Women's Army Corps. She stepped down as college president in 1942, only to resume leadership in 1946–1947. She died at her Daytona Beach home on May 18, 1955, and is buried on the Bethune-Cookman University campus.

In her last summation of her beliefs, titled "Last Will and Testament" and published in *Ebony* magazine just after her death, she wrote: "Faith, courage, brotherhood, dignity, ambition, responsibility—these are needed today as never before. We must cultivate them and use them as tools for our task of completing the establishment of equality for the Negro. We must sharpen these tools in the struggle that faces us and find new ways of using them. The freedom gates are half-ajar. We must pry them fully open." (Opposite, courtesy of the Library of Congress; above, courtesy of the State Archives of Florida.)

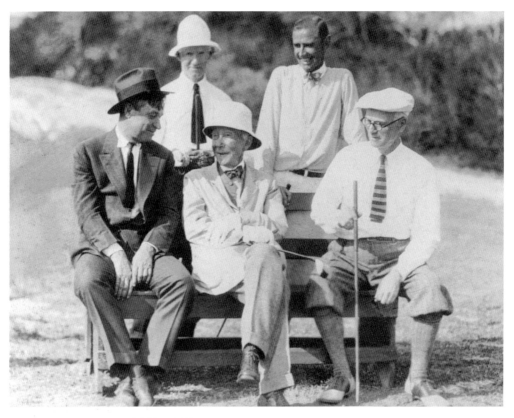

John D. Rockefeller (1839–1937)

The man whose name is synonymous with wealth, John D. Rockefeller made his winter home in Ormond Beach in 1918 when he bought the Casements, across from the Ormond Hotel. He had considered Augusta, Georgia, for golfing. He thought about Seabreeze for the climate. But after wintering at the Ormond Hotel, he found Ormond had both. The gaunt, elderly, hairless (he had alopecia since his 60s) Rockefeller became a familiar figure in Ormond and Daytona. And many an area child treasured the dimes he famously handed out. Rockefeller is shown here, seated at center, chatting with Will Rogers on the golf course. (Courtesy of Halifax Historical Museum.)

The Harding-Kling family

The only president of the United States associated with Daytona Beach is a name usually found near the bottom of lists of presidential greatness, Warren G. Harding. Harding's father-in-law, Amos Kling, bought a winter home in Daytona that still stands at 220 Magnolia Avenue. The Hardings visited town many times. Harding came by town on a river cruise in 1921, just before he took office, and in 1923, not long before he died in office. Shown here are Harding's father, Dr. George Tryon Harding, and wife, Phoebe, in front of the Peninsula Women's Club. (Courtesy of Halifax Historical Museum.)

Basil F. "Ben" Brass (1891–1966)

Basil Franklin Brass was the first mayor of the expanded consolidated city of Daytona Beach. He was a natural choice, having chaired the committee that campaigned for the measure. Brass brought in a professional city manager and a new police chief but served only one term. Opponents claimed the new city was being overmanaged by outsiders, and the new mayor, Edward Armstrong, undid many of the reforms. Brass remained one of the city's more prominent private attorneys. His clients included the family of Cuban dictator Fulgencio Batista. (Courtesy of Halifax Historical Museum.)

Billie Byington Baggett (1886–1957)
Billie Baggett became the third mayor of the newly consolidated city of Daytona Beach in 1930. He arrived at a trying juncture when the city wrestled with deficit spending, bond default, and the effects of the Great Depression. Winning as a reform candidate, he managed to settle with city bondholders and presided over the opening of Daytona Beach Regional Airport. He served one term and did not stand for reelection. Baggett founded Baggett-Wetherby Funeral Home in 1917, a business still going today as Cardwell, Baggett and Summers Funeral Home & Crematory. (Courtesy of City of Daytona Beach.)

William "Bill" McCoy (1877–1948)

"To live outside the law, you must be honest," Bob Dylan once sang, and that was the ethos of William "Bill" McCoy. It was something the famed rumrunner was noted for—a guy one could trust while violating the Volstead Act. He is shown here in 1924.

"I lived with my parents in Daytona, Florida, and built yachts. I built one for Frederick Vanderbilt and another for Maxine Elliot. Then, in 1921, my parents died. Shortly after this, my bulldog died. That was the last tie of my affections to Daytona, so I decided to go to sea," he told the *New York Times* after his arrest.

In 1921, he bought a schooner, the *Tomoka*, also called the *Arethusa*, and made his first liquor run between Nassau, Bahamas, and Savannah, Georgia, bringing in 1,500 cases. The author of his biography, *The Real McCoy* (1931), estimated McCoy moved 175,000 cases of alcohol in his career, mostly Scotch and rye.

But in November 1923, the *Tomoka* was seized by the US Coast Guard. "I have no tale of woe to tell you," the *New York Times* quotes him as saying at his hearing. "I was outside the three-mile limit, selling whiskey, and good whisky, to anyone and everyone who wanted to buy."

He served nine months in a New Jersey jail—not a penitentiary, as he later emphasized to journalists who wrote about him. He returned to Florida complaining that rum-running was no fun anymore. "It's a business now and I'm not that kind of businessman," he told his biographer.

He died of complications from food poisoning on December 30, 1948, aboard his 49-foot boat the *Blue Lagoon*, anchored in Stuart, Florida. He was 71. Some say the phrase "the real McCoy" remains as a testament to the quality of his product, but the phrase had been in use long before his birth. (Courtesy of the Mariners' Museum, Newport News, Virginia.)

Richard H. LeSesne (1880–1946)
Nobody captured the early years of beach racing like Richard LeSesne. He took portraits of drivers, panoramic shots of the cars, races, and crowds, postcards of events and town sights, and even aerial images. Born in Georgia, he arrived in Daytona sometime around 1903 and opened a Beach Street photographic studio, later moving it to Palmetto Avenue. He died in 1946. (Courtesy of Halifax Historical Museum.)

Elizabeth Butler Custer (1842–1933)
Elizabeth "Libby" Custer was 34 when her larger-than-life husband, Gen. George Armstrong Custer, died in the Battle of Little Bighorn in 1876. She never remarried and spent her long remaining life as a writer and lecturer, defending her late husband and rehabilitating his image. Starting in the 1920s, she regularly wintered in Daytona Beach at the Osceola Gramatan Hotel and at least once consulted a Cassadaga spiritualist for word about her husband. She is shown here in an 1865 portrait with General Custer (left) and his brother Thomas Custer. (Courtesy of the Library of Congress.)

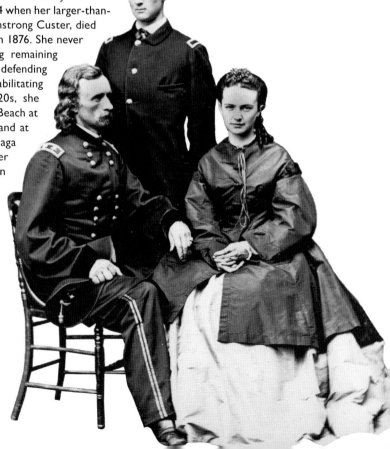

Walter C. Hardesty (1880–1935)

Walter C. Hardesty had the timing to arrive here from Ohio just before the Great Florida Land Boom got underway. His ambitious Rio Vista subdivision in Holly Hill featured Spanish-style stucco homes, horse trails, and canals. He had Roman-style columns constructed by the railroad tracks to attest to the stateliness of his vision, shown here. Only 30 houses and the Riviera Hotel got built before the land boom collapsed. (Photograph by Mark Lane.)

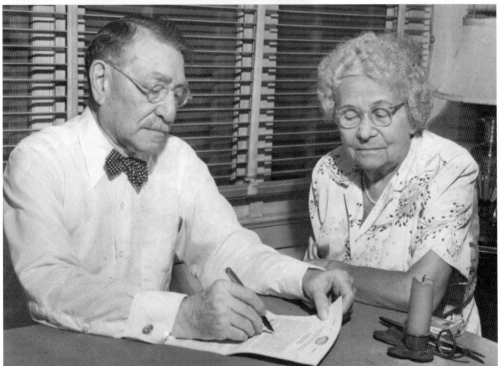

Julius Davidson (1870–1963)

In 1928, after the land boom collapsed and Florida was getting an early taste of the Great Depression, Julius Davidson and his son Herbert Davidson arrived from Chicago after purchasing the 4,400-circulation *Daytona Beach News-Journal*. He had built a fortune in Kansas City, retired to Chicago, then threw himself into newspapering, overseeing expansion of the paper and even its entry into radio. He also founded the Daytona Symphony Society. "Keep up the quality of the newspaper and you are bound to win out," was his oft-stated business plan. He is pictured here with his wife, Rose, in 1950. (Courtesy of Halifax Historical Museum.)

Simon J. Peabody (1851–1933)

Simon Peabody is still a familiar name because Peabody Auditorium was named in his honor. A winter resident who made his fortune in timber, Peabody donated the land for the auditorium and $11,000 toward its $25,000 cost. Completed in 1920, the auditorium was destroyed by fire in 1946. The current Peabody Auditorium was built in 1949. (Courtesy of Halifax Historical Museum.)

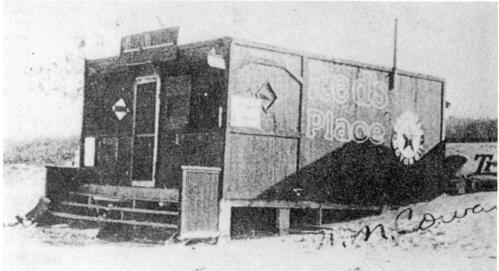

Winder "Red" Cowan (1892–1980)

Red Cowan arrived in Daytona in 1919, the year Prohibition started. He knew both sides of the law as a rumrunner and one of Daytona's first motorcycle policemen from 1921 to 1927. In the early days of aviation, his place on the beach, Red's Place, was a refueling station for airplanes, but it offered other fueling, too. It was swept out to sea in a 1932 storm. "It was built so strong, it didn't come apart; it just floated away like a houseboat," he told a reporter. (Courtesy of the State Archives of Florida.)

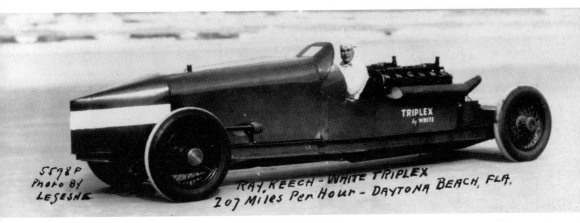

Ray Keech (1900–1929)

Keech was a different kind of driver than polished aristocrats like Henry Segrave and Malcolm Campbell. He started as a dirt-track racer and truck driver. Fred Booth described him as "blocky, rough-looking." After several tries, driving the *Triplex Special* powered by three V-12 aircraft engines, he broke the record on April 22, 1928, reaching 207.552 miles per hour. Keech would not get a chance to repeat the feat. On June 15, 1929, only 16 days after winning the Indy 500, Keech was killed in a four-car wreck at the Altoona Speedway in Pennsylvania. Keech Street was named for him. (Courtesy of the State Archives of Florida.)

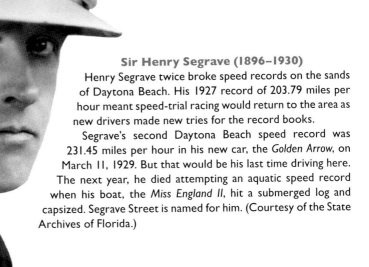

Sir Henry Segrave (1896–1930)

Henry Segrave twice broke speed records on the sands of Daytona Beach. His 1927 record of 203.79 miles per hour meant speed-trial racing would return to the area as new drivers made new tries for the record books.

Segrave's second Daytona Beach speed record was 231.45 miles per hour in his new car, the *Golden Arrow*, on March 11, 1929. But that would be his last time driving here. The next year, he died attempting an aquatic speed record when his boat, the *Miss England II*, hit a submerged log and capsized. Segrave Street is named for him. (Courtesy of the State Archives of Florida.)

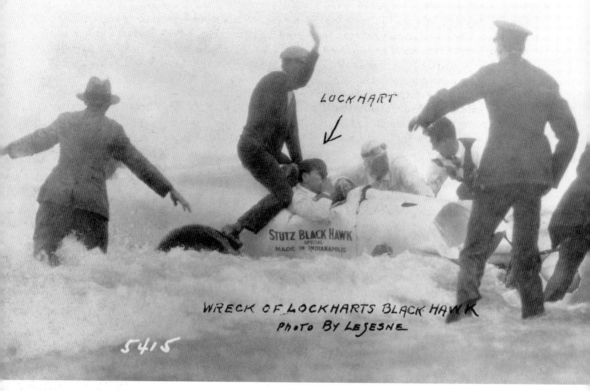

LOCKHART

STUTZ BLACK HAWK
SPECIAL
MADE IN INDIANAPOLIS

WRECK OF LOCKHARTS BLACK HAWK
PHOTO BY LESESNE

5415

Frank Lockhart (1903–1928)

Frank Lockhart's was the first racing death in Daytona Beach. The legendary driver and mechanic had a meteoric career, winning the Indianapolis 500 the first time he drove the race as a substitute driver in 1926. The next year at Indianapolis, he broke the 120-miles-per-hour mark.

On February 28, 1928, he tried for the land speed record in Daytona Beach despite iffy weather. Lockhart lost control of the car, the 16-cylinder Stutz *Black Hawk*, and spun into the ocean. "We heard a ringing crash. The car bounded and swerved, skidded diagonally across the beach in two end-for-end loops and still on its wheels, shot nose first into the ocean," wrote *News-Journal* reporter Fred Booth. "Dozens of us ran pell-mell into the water up to our chins and tried to pull Lockhart out of his wreck." Lockhart was rescued and his car towed to shore. Photographer Richard LeSesne was among those watching and captured this dramatic photograph.

Lockhart had the *Black Hawk* rebuilt, came back, and tried again. On April 25, 1928, driving at close to 200 miles per hour, a rear tire blew out: "Before our horrified eyes the tire flew to pieces," wrote Booth. "Skidding, barrel rolling, bouncing and bounding high into the air, the car bore down upon us." Lockhart was flung 51 feet. He was taken to Halifax Hospital, where he was pronounced dead. He was barely 25. (Courtesy of the State Archives of Florida.)

Sigurd "Sig" Haugdahl (1891–1970)

A native of Norway, Sig Haugdahl made a name for himself as a motorcycle racer, dirt-track racer, race promoter, and mechanical innovator. He arrived in Daytona about 1920, opened a garage, and immediately attacked the world speed record. On April 7, 1922, driving his *Wisconsin Special* (so-called because it was powered by a Wisconsin aircraft engine) on the sands of Daytona Beach, he became the first driver to run a three-minute mile. Although widely reported, the sanctioning body at the time, the American Automobile Association, did not recognize the record.

After the speed trials had moved from Daytona Beach, Haugdahl worked with the city to lay out the beach course for a different kind of racing. Bill France, who had recently arrived in town, entered his race and came in fifth. But overall, the 1936 race was a mess: cars got stuck in the sand, it had to be called off prematurely, and the real winners were disputed. Worse, the city lost $22,000 on the venture. The next year, the Elks Club sponsored the race, and though it went more smoothly, the race still lost money. Haugdahl had enough and went back to running his garage, and Bill France kept the races going.

This photograph shows Haugdahl at his garage. Another of his advanced creations, a rocket-powered car, can be seen behind him. He died in Jacksonville in 1970. (Courtesy of the State Archives of Florida.)

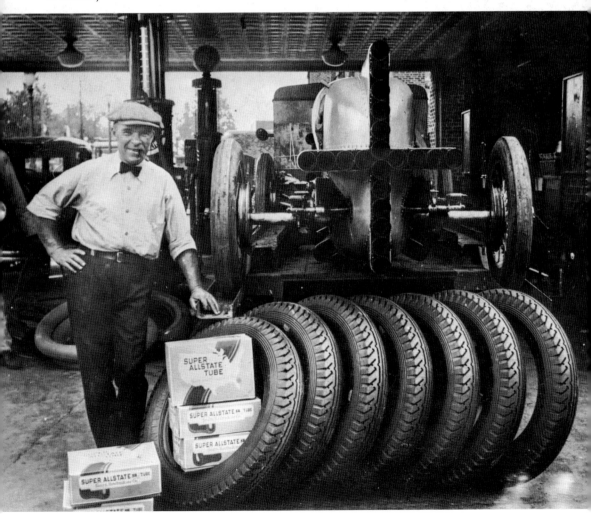

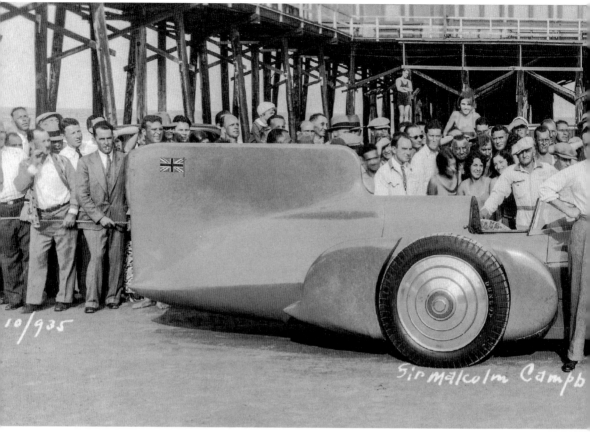

10/935

Sir Malcolm Campb

Sir Malcolm Campbell (1885–1948)

Sir Malcolm Campbell's speed records were the events that made Daytona Beach think of itself as the World's Most Famous Beach. The world's sporting press, including newsreel teams, arrived to cover the events. The Associated Press called the town the "World's Battleground of Speed." Crowds gathered, and the city's fire station sirens sounded when each new record was attempted. Seven speed records were set in Daytona Beach between 1927 and 1935, and four of them were set by Campbell.

A beaming Campbell is shown here in a 1931 photograph with his legendary car, the *Bluebird*, in front of the Ocean Pier, surrounded by press, fans, well-wishers, and curious tourists. For a time, the city's logo depicted the *Bluebird* on the beach in front of the Ocean Pier. Five tons, 28 feet long, powered by a 12-cylinder engine like the ones used in Spitfire fighter planes, and streamlined when the style was futuristic, it was an amazing machine. The car was on display for years at the Museum of Speed in South Daytona.

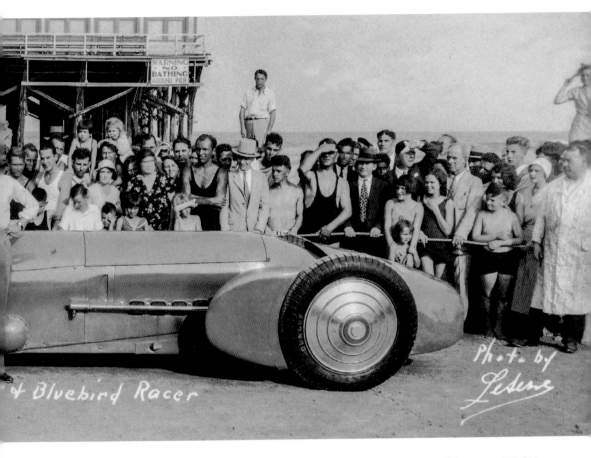

+ Bluebird Racer

Ph+t+ by LeSesne

Campbell's final visit to Daytona Beach was in 1935; on March 7, he was clocked driving at 276.816 miles per hour. "When Campbell returned to the timing tower after his record run, the rear tires were so deeply frayed, the severed cords spread out on the beach like the fringe of a rug," wrote *News-Journal* reporter Fred Booth.

Despite the success, this would be the end of the speed record era for Daytona Beach. Later that same year, Campbell would break the 300 miles-per-hour mark at the Bonneville Salt Flats in Utah. He and the record setters never came back. (Photograph by Richard LeSesne, courtesy of Halifax Historical Museum.)

Edward Armstrong (1879–1938)

As mayor during the worst days of the Great Depression, Edward Armstrong had a reputation as a "Northern big city political boss only transplanted into Daytona, into the South," in the words of one historian. He is remembered for getting the boardwalk and Bandshell built but died on the day of the official dedication, New Year's Day 1938. A coquina rock on a pedestal near the Bandshell was built as the Edward H. Armstrong Monument, but even after his death he was politically controversial. The city commission voted down putting up a plaque on the monument, and to this day, there is a blank space where one would go.

He is best remembered for his confrontation with Florida governor David Sholtz, who had been a political foe of Armstrong's well before he was elected governor. Knowing the governor was about to remove him office, Armstrong had his wife, Irene, named mayor in his stead.

The clash came to a head on New Year's Day in 1937, when the governor sent National Guard troops to remove the Armstrongs. They surrounded city hall but were met by armed police and city employees. It was a standoff. Meanwhile, officials barricaded themselves inside and busily had city garbage trucks haul away documents.

"City Hall an Armed Fortress . . . Coppers Hold Riot Guns at Windows," was the headline in the *Daytona Beach News-Journal*, a strongly anti-Armstrong publication. "The Battle of Daytona Beach," it called the confrontation. Media around the country covered the faceoff with armed police, troops, and the lady mayor. Because this happened in the last days of Sholtz's term, Armstrong believed he could run out the clock and see what the new governor would do.

It worked. It all ended after five days, as the new governor took office, assessed the situation, and decided he had no interest in interceding in Daytona Beach politics. Armstrong went on to be elected to a fifth term that December by a landslide 5-1 margin but died before he could take office. (Courtesy of Leonard Lempel.)

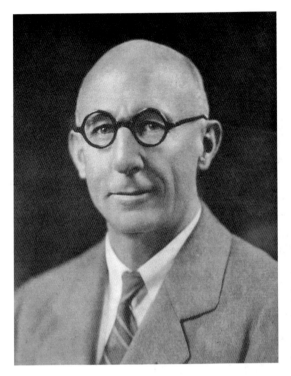

Pleasant Daniel Gold (1876–1965)
Much of what is known about Volusia County's past is through the efforts of a man with the mellifluous name of Pleasant Daniel Gold. The former insurance man was the author of the *History of Volusia County*, published in 1927, and three-term mayor of Seabreeze. He also wrote *In Florida's Dawn: A Romance of History*, a historical novel about Pedro Menéndez de Avilés and Jean Ribault. (Courtesy of Halifax Historical Museum.)

Ianthe Bond Hebel (1884–1974)
Ianthe Bond Hebel arrived in Daytona in 1898, a teenaged girl in a horse-drawn wagon carrying the family's prized clock in her lap. Her life, a *Daytona Beach News-Journal* editorial observed, "bridged the era of the horse and buggy, the automobile, air travel and space flight." She founded the Halifax Historical Society and wrote often about the area's history. She wrote much of and edited the *Centennial History of Volusia County*, published in 1955. (Courtesy of Halifax Historical Museum.)

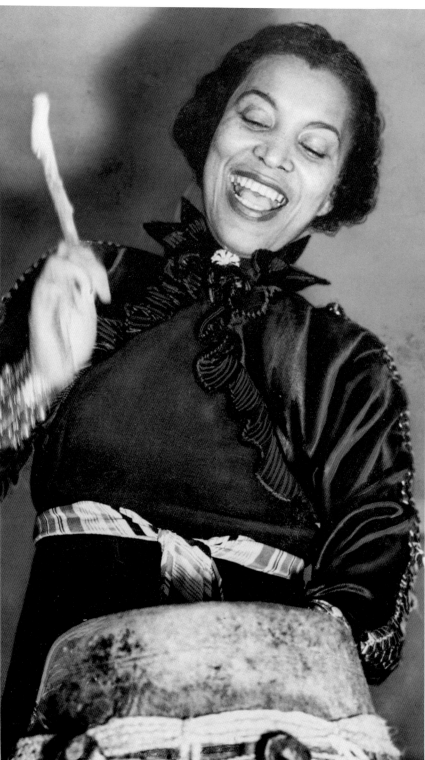

Zora Neale Hurston (1891–1960) (OPPOSITE PAGE)
Zora Neale Hurston, novelist, playwright, folklorist, and Harlem Renaissance writer, is best known to modern readers for her novel *Their Eyes Were Watching God*, which is on many high school reading lists and was made into an award-winning television movie in 2005. Mary McLeod Bethune, impressed by Hurston's 1933 musical and dramatic revue, *From Sun to Sun*, based on black folklore themes, invited her to come to Daytona Beach and set up a drama department at Bethune-Cookman College. That the strong-willed Bethune and fiercely independent Hurston would soon clash seemed foreordained. Citing lack of resources and artistic freedom, she left in 1934. Hurston is shown opposite in a 1937 *New York World-Telegram* photograph.

But she returned to Daytona Beach in 1943 and bought the *Wanago*, a 32-foot, 20-year-old houseboat and lived on the Halifax River, mooring it at Howard Boat Works.

It was an idyllic time for Hurston. "The Halifax River is very beautiful and the various natural expressions of the day on the river keep me happier than I have ever been before in my life," she wrote in a letter. "Here, I can actually forget for short periods the greed and ultimate brutality of man to man. I have back my faith in the ultimate good that I was losing for a while."

She took the boat up to New York City in 1944 but soon returned, buying a new houseboat, the *Sun Tan*. Somehow she also found time to be married for 10 months in 1944 to James Howell Pitts. For the wedding license he gave his address as Brunswick, Georgia; she gave hers as Daytona Beach.

She left for Honduras in 1947 and would not be back again until 1956, when she was honored at the Bethune-Cookman commencement. She died in 1960 in a Fort Pierce nursing home.

Her books went mostly out of print until the 1970s, when she was rediscovered and championed by Alice Walker, who in 1973 wrote of finding Hurston's unmarked grave in the weeds of Fort Pierce cemetery. By 2003, her revival was such that she was honored by a commemorative postage stamp, and each year the Zora Neale Hurston Festival of Arts and Humanities draws thousands to Eatonville, Florida. (Courtesy of the Library of Congress.)

Lee Bible (1887–1929)

On March 13, 1929, Lee Bible, a local mechanic and garage owner, died in a violent car wreck after clocking more than 200 miles per hour in the *Triplex Special*, the car Ray Keech used to break the speed record a year before. Bible swerved toward the dunes; his car hit and killed a newsreel photographer and rolled over several times. The Reverend Andrew Jenkins, who sometimes recorded as Blind Andy, wrote and recorded a song about the crash: "In a moment of time, in the midst of his prime, the brave young mechanic was dead," he sang in "Tragedy on Daytona Beach." (Courtesy of the State Archives of Florida.)

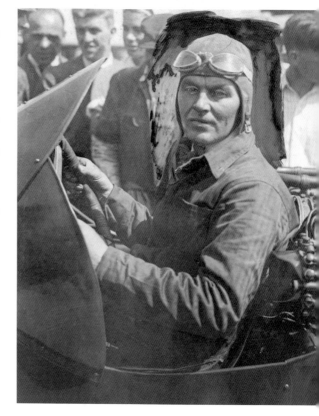

Annie Oakley (1860–1926)

Among the celebrities visiting Daytona in the 1920s was Annie Oakley, though not on purpose. An accident in November 1922 on Dixie Highway left her pinned under her Cadillac. A motorist freed her and drove her to Dr. Bohannon's Hospital and Sanitarium. She was on braces and crutches when she limped out of town the next January. She said she received more than 2,000 notes from well-wishers. But she soon was back doing shows and could still hit pennies tossed in the air at 20 feet, firing a rifle while standing on her one good leg. (Courtesy of the Library of Congress.)

CHAPTER THREE

Town into City

1945–1975

As World War II ended, Daytona Beach, along with Florida as a whole, saw an influx of new residents and visitors. Travel that had been put off because of wartime gas rationing now was scheduled. People who trained here during the war came back. Locals who had served in the armed forces returned home. Between 1940 and 1950, the town grew by a third, to 30,187 people. They came for the climate. They came for the beach. And now they came for the racing, too.

With the loss of the speed trials in the 1930s, the city, promoters, and racers looked for ways to keep beach racing going. Sig Haugdahl, a racer, promoter, and garage owner, came up with a 3.2-mile race, half on the beach and half on Atlantic Avenue. Among the racers in 1936 was town newcomer Bill France. That first race was a disaster; cars got stuck in the sand, the winners were disputed, the race ended prematurely, and the city lost $22,000 at a time when it was close to broke. Despite this inauspicious start and the loss of city sponsorship, the beach races continued until interrupted by the war. And soon France took over the lead role in organizing them.

In 1947, France huddled with racers, race car owners, and promoters at the bar atop the Streamline Hotel, and the result was the formation of the National Association for Stock Car Auto Racing, or NASCAR, on February 21, 1948. Beach racing continued under NASCAR auspices until 1958.

But as happened with the speed trials, the cars became too fast and too heavy for even the hard sand beach. The crowds grew larger and harder to corral and control. As the beachside became more populated, residents began complaining about the noise and congestion from the events. The races had to move.

France wanted a more modern high-speed racecourse with dramatically banked turns. The Racing and Recreation Facilities Authority was created to advance that dream in 1954, and the city leased it a site near the airport to build the facility. Daytona Motor Speedway Corporation signed an agreement to build and operate the track in 1955.

"It is anticipated that speeds exceeding 140 mph . . . may be exceeded here in perfect safety," the *New York Times* said of France's audacious plans in 1956. The piece hailed it as "the most advanced step in racing and testing available in the country."

Ground-breaking was in 1957, and the first Daytona 500 ran in February 1959. Daytona would be the capital of motorsports from that point on.

The Daytona 200, a motorcycle race, also resumed in 1947 with the end of World War II. "For four days last month the resort city of Daytona Beach could hardly have been noisier—or in more danger—if it had been under bombardment," reported *Life* magazine in 1948. And with the races came the crowds that flocked here for bike weeks. The motorcycle races were held on the beach until 1961, when they, too, moved to the speedway.

In addition to race fans, students on spring break started discovering Daytona Beach in the 1960s. At first, city promoters did little more than steal business from Fort Lauderdale after that city's spring break was immortalized in the movie *Where the Boys Are*. The event gained enough numbers that there was a near-riot in 1964 with more than 100 arrests. As a result, drinking was banned on the beach in 1966.

This era also saw the breakdown of segregation in Daytona Beach. Although the milder racial atmosphere of Daytona Beach was often commented upon at the time, the city was still strictly racially segregated by law and by custom. A separate black beach resort was founded in Bethune Beach in the 1940s because blacks were not allowed on the beach in Daytona Beach. Black citizens had to sue in federal court in 1951 to be allowed into Peabody Auditorium.

But things started changing in the 1950s. City buses were integrated by 1956. The first downtown lunch counters were integrated in 1960. Blacks were able to use the city golf course by 1961, and downtown movie theaters opened to both races by 1963. Soon after the 1964 Civil Rights Act, the last vestiges of legalized racial segregation quickly crumbled. In 1964, Daytona Beach voters elected the first black city commissioner in modern times, James "Jimmy" Huger.

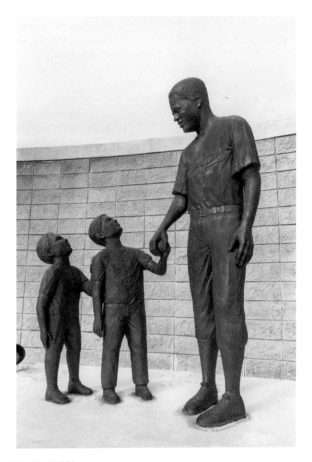

Jackie Robinson (1919–1972)

On March 17, 1946, Jackie Robinson, playing for the Montreal Royals, took his place at Major League Baseball's first integrated game, a spring-training exhibition game at what was then City Island Ball Park. Now it is named Jackie Robinson Ballpark in his honor. A statue of Robinson, shown here, stands at the park's southwest entrance.

The game was played after Robinson had been turned away from playing at Jacksonville and Sanford. (The city cancelled a later game slated for DeLand on the pretext of lighting problems. It was to have been a daytime game.)

But Robinson played without incident at Daytona Beach at a 3:00 p.m. game under threatening skies. "Playing under terrific pressure, Robinson conducted himself well afield during his five-inning stint," *Daytona Beach News-Journal* sports writer Bernard Kahn wrote.

"There were a few catcalls and all, but nobody made a big deal of it," recalled Phil Burroughs, who watched the game when he was 15.

"Everybody from our part of town wanted to see him. Old people and small children, invalids and town drunks, all walked through the streets, some on crutches, and some people clutched in the arms of friends, walking slowly on parade to the ball park to sit in the segregated section," Mets third baseman Ed Charles told a Robinson biographer.

An editorial in the *New York Times* saw Robinson's reception in Daytona Beach as a promising sign for the future. "The crowd at Daytona Beach took Robinson's first appearance in a matter-of-fact manner, according to reporters. There was friendly applause and no jeers," it said. "If the crowds that watch him in Montreal and elsewhere in International League cities accept his appearance as a matter of course, as did the Daytona Beach crowd of 4,000, another racial barrier will be broken down." (Photograph by Mark Lane.)

William Henry Getty "Big Bill" France (1909–1992) (OPPOSITE PAGE)

If Bill France had only built one major sports facility in an unlikely place, he would be famous. If he had just formed a national sports sanctioning body, he would have had a pretty amazing career. Instead, he built two legendary racetracks, in Daytona Beach and Talladega, Alabama, and founded NASCAR and guided the organization on to explosive growth as a benevolent dictator, a phrase used by more than one commentator.

The story is often told of how Bill France arrived in Daytona Beach in 1934 because his car, a Hupmobile, broke down here. He denied this more than once, but it was an excellent story, one that suggested he was fated to be here.

He quickly found work as a brake mechanic for Saxton Lloyd's Daytona Motors dealership, then set up his own gas station on Main Street. In 1936, he helped Sig Haugdahl set up the first beach/road race in Daytona Beach. (He also drove in that ill-fated race, coming in fifth.) By 1938, he was running the races.

In 1947, with racing and consumer car manufacturing resumed after World War II, France moved toward his vision of a bigger organization to bring car racing out of the county fairgrounds and improvised races to become a major sport, with a broader fan base that would follow the racing calendar as avidly as football or baseball season. He is shown here that year presenting a trophy to driver Robert "Red" Byron.

France brought together more than two dozen racing promoters, drivers, and car owners to the Ebony Room of the Streamline Hotel on Atlantic Avenue for a multiday meeting in December 1947, and from those sessions came NASCAR, with France as president and majority stockholder. In February 1948, the first NASCAR-sanctioned race ran on the beach sands of Daytona.

But the races were outgrowing the beach venue. The crowds grew larger and harder to manage. The once-empty south beach was becoming more populated, and residents were complaining. France envisioned a faster, more modern track: the world's greatest speedway and right here in town. Daytona International Speedway was the result, built and ready for its first race in only 15 months. The first Daytona 500 was held on February 22, 1959. Racing has never looked backed. (Courtesy of the State Archives of Florida.)

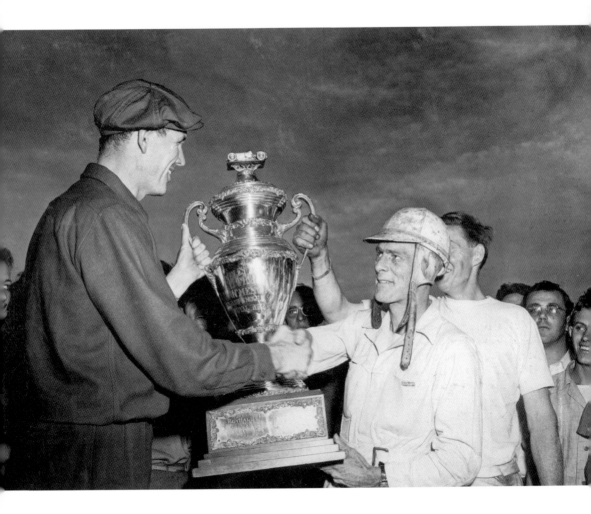

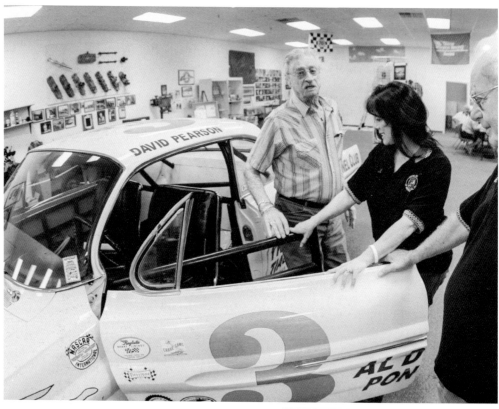

Ray Fox (1916–2014)

Ray Fox became a NASCAR legend when the car he built in less than two weeks for the Daytona Beach Kennel Club took Junior Johnson first across the finish line at the 1960 Daytona 500. It was a win that swept in the drafting era of stock-car racing. Fox, who moved to Daytona in 1946, had 14 wins as a car owner. He is shown here in 2005 inspecting a replica of his 1961 Pontiac. (Photograph by David Tucker, courtesy of the *Daytona Beach News-Journal*.)

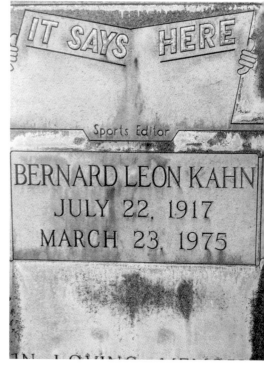

Bernard "Benny" Kahn (1917–1975)

For three decades, Bernard Kahn's sports column *It Says Here* was the most-read feature in the *Daytona Beach News-Journal*, always topped by the familiar illustration of an open newspaper. No wonder it also topped his tombstone. A witness to the birth of NASCAR, the press room at Daytona International Speedway was named for him. (Photograph by Mark Lane.)

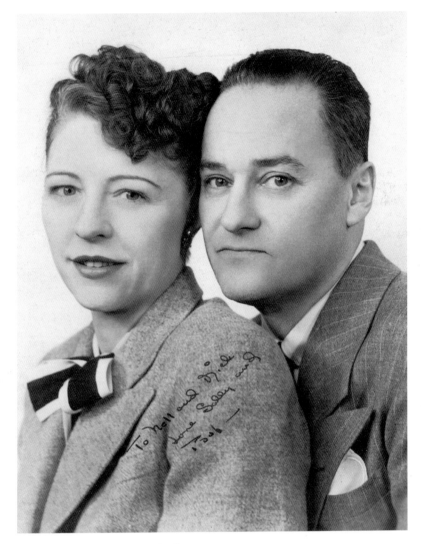

Robert Ingersoll Wilder (1901–1974)

Robert Wilder mined his Daytona Beach childhood for sprawling novels, some of which he adapted for successful movies. His first novel, *God Has a Long Face*, was said to be inspired by the life of Charles Burgoyne, although it is difficult to find all that many similarities between Burgoyne and Gen. Wallis Burgoyne beyond a surname and a larger-than-life man with ready capital remaking a frontier Florida town.

Wilder graduated from Seabreeze High School, served in World War I, and worked, according to one reviewer, as "a soda jerker, a ship fitter, a theater usher, a chauffeur, and a radio executive." He was a rewrite man and columnist for the *New York Sun* from 1935–1944 according to his *New York Times* obituary, but "he found newspaper work unremunerative and decided to write himself out of it." His novel about corrupt small-town Florida politics, *Flamingo Road*, was turned into an unsuccessful play but a successful movie starring Joan Crawford in 1949. It was adapted again into a television series from 1980 to 1982, because stories about Florida corruption never go out of style.

Other novels included *Bright Feather*, set in the Seminole Wars, and *Wind from the Carolinas*, about a family of Southern loyalists who resettle in Bermuda after the Revolutionary War. Wilder died in 1974 in La Jolla, California. He is shown here with his wife, Sally. (Courtesy of Halifax Historical Museum.)

Fred "Bonehead" Merkle (1888–1956)

By all accounts, Fred Merkle was a jewel of a guy and an outstanding baseball player. But baseball is a game of long memory, and a single error in the second season of his Major League career is the reason he is known in baseball history as Bonehead Merkle.

Merkle played from 1907 to 1926, a first baseman with 82 home runs and a batting average of .273 in a career that started in what was known as the dead-ball era because of the smaller number of hits and home runs. His unfortunate nickname came about after a game on September 23, 1908, when the Chicago Cubs faced the New York Giants at the Polo Grounds in New York, with the score tied and two out.

The 19-year-old Merkle, hitting for the Giants in the ninth inning, made it to first base. The next single drove in the winning run. Or seemed to. The runner touched home plate. The crowd went wild and spilled onto the field as Merkle headed to the dugout without touching second base.

Cubs second baseman Johnny Evers retrieved the ball—or some other ball, accounts vary—tagged second, and Merkle was called out, making the winning run void. The umpire declared the game a tie since the crowd was milling around the field, the sky was darkening, and resuming play was not possible. The Cubs would win the pennant and the series. The New York press and fans were savage in their recriminations and forever attached the modifier "Bonehead" to his name.

The mistake became baseball folklore and haunted Merkle. He retired to Daytona Beach, where he started a fishing tackle business. He is shown here making floats in the workshop of Zephyr Slip Casting Floats on Loomis Avenue.

"Reticent Fred Merkle, perhaps the most maligned man in the history of baseball, has gone where the jibes of the wiseacre wolves can't hurt him anymore," wrote *Daytona Beach News-Journal* sportswriter Bernard Kahn on his death in 1956. Merkle is buried at Daytona Memorial Park under a gravestone marked only with the names of his parents. Even in death, he wanted to be shielded from the abuse by New York fans. (Courtesy of the State Archives of Florida.)

Ferdinand the Bull (1940s–1950s)
Beginning sometime around the start of the 1940s, tourists would pose for photographs atop Ferdinand the bull, a docile animal usually found tied up near the Daytona Beach Pier. Ferdinand became a familiar sight on the beach for almost two decades and often shows up in photographs and postcards. He is shown here in a 1956 photograph. In the 1940s, the bull beach concession was operated by Hollywood actor and sideshow and vaudeville tall man, the seven-and-a-half-foot R.E. "Tex" Madsen (1897–1948). Joe McLain worked with Ferdinand in the 1950s. (Courtesy of the State Archives of Florida.)

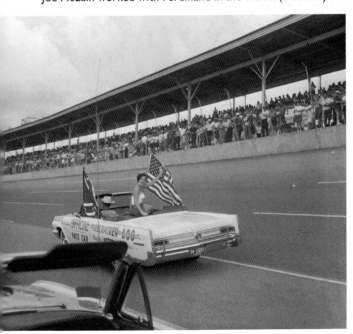

Miss Firecracker, Miss Dixie (1946–1968)
The race that was called the Firecracker 240 and later the Firecracker 400 was traditionally the highlight of the Fourth of July holiday. At the same time, the Dixie Frolics were held at the Boardwalk, cumulating in the Miss Dixie beauty contest. Separately, a Miss Firecracker was chosen to preside over the Speedway events. Here, the 1963 Miss Firecracker takes a lap before the Firecracker 400. (Courtesy of State Archives of Florida.)

Brownie the Town Dog (1939–1954)

Everybody in downtown Daytona Beach knew Brownie, a plain brown dog of indeterminate breed that lived in a doghouse near the taxi stand on Orange Avenue. A veterinarian would give him his shots for free, a downtown steakhouse kept him fed, and a photographer sold photographs of him to raise money for his veterinary bill after he was hit by a car. Some said he had a way of cozying up to random people who were ill and keeping them company at the city's downtown park benches. He followed children and cozied up to passengers at the taxi stand. He had the run of downtown, was issued the city's first dog license, and had an account in his name at Florida Bank and Trust until his death in 1954.

After he died, Mayor Jack Tamm gave a eulogy to 75 assembled mourners. Brownie was buried under a tombstone in Riverside Park that is still there, near Jackie Robinson Ballpark and the bust of Charles Burgoyne. It says: "Brownie, the Town Dog 1939–1954, a Good Dog." (Courtesy of Halifax Historical Museum.)

Ralph W. Richards (1890–1975)

Before it was banned under the 1968 Florida Constitution, a politician could hold any number of offices at the same time. And nobody in Daytona Beach politics did this longer and to more effect than Ralph Richards. He served 10 terms as city commissioner, which overlapped with his four terms as a Volusia County commissioner.

Recruited into city politics by Mayor Edward Armstrong, he was among the commissioners who barricaded themselves in city hall at the end of 1936 after Gov. David Sholtz tried to remove them from office. After Armstrong died in 1938, Richards cast the deciding city commission vote to pick Frank Couch as mayor. The next year, Richards was found guilty of accepting a $10,000 bribe to cast that vote. He was pardoned by Gov. Spessard Holland before he served any jail time, and resumed his political career.

Daytona Beach News-Journal editorial writer Mabel Norris Chesley described him in 1958 as "an affable man with a knack for turning criticism into an advantage by disarming the critic with a joke in return." *News-Journal* city hall reporter Bob Desiderio described him shortly before his death as the man "who charmed more northeast Volusians out of their votes than any other politician."

He suffered a stroke during his campaign for a fifth term on the county commission in 1966 and had to drop out of the race and then out of politics generally. He died in 1975. (Courtesy of the *Daytona Beach News-Journal*.)

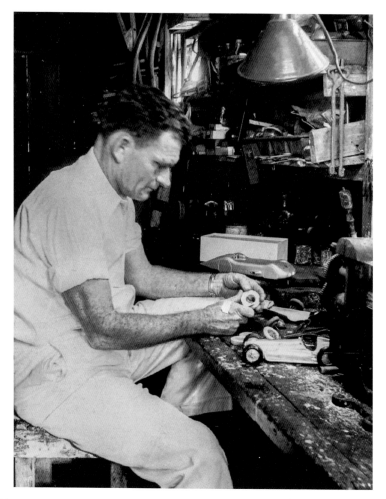

Lawson Diggett (1901–1979)

Today, Lawson Diggett might have been called an outsider artist. He made detailed models of almost everything that impressed him in Daytona Beach. To say that model-making was Diggett's hobby would understate things. Models of buildings, racing cars, and ships were an obsession. He made elaborate and accurate dioramas of beach racing crashes. He never married, and told people that because he seldom slept more than four hours, he had more time to fashion hundreds of models out of wood, clay, scraps of metal, leather, and glass.

He knocked down the walls in his home to make more room for the models, dioramas, artifacts, and back issues of newspapers. Over time, there was barely room to move around.

When he died in 1979 at age 78, he left everything to the Halifax Historical Museum, which took years sorting through more than 300 automotive models (mostly racecars from the beach-racing era), a 10-foot model of the *Aquitania*, scrapbooks filled with yellowed *Daytona Beach News-Journal* clippings about beach racing, obsessively detailed diaries, and boxes of the hundreds of photographs he had taken.

But his masterpiece was a 14-foot-long model of the boardwalk as it looked in 1938, now at the Halifax Historical Museum. It contains 1,330 figures. They are assembled at the Bandshell listening to a concert. They are swimming, walking on the boardwalk, renting beach umbrellas, gathering in clusters, and idling on the sidewalk next to parked cars. There is the Daytona Beach Pier, the clock tower, the pool south of the pier, the lifeguards' white towers, green cars, and blue beach umbrellas. (Courtesy of Halifax Historical Museum.)

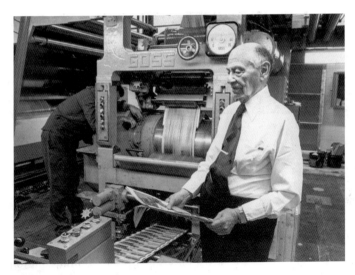

Herbert M. Davidson (1895–1985)

In 1928, Herbert M. Davdison and his father, Julius Davidson, bought the *Daytona Beach News-Journal*, then a small newspaper with a circulation of 4,400. The elder Davidson tended to the business end of things; the younger, a Columbia School of Journalism grad with newspaper experience that included the *Kansas City Star*, edited the paper. Herbert's wife, Liliane Davidson, was a reporter, columnist, copy editor, and librarian. Pictured below are the paper's Orange Avenue offices as they looked when the Davidsons bought the paper.

After a modest profit the first year, the paper would not see a profitable year again until the Great Depression ended. During those dire times, the paper resorted to paying employees in scrip, coupons redeemable with advertisers who would in turn use them to pay for advertising. It was also during the Depression that the evening paper started a morning edition.

In 1967, the paper moved to its present site on Sixth Street. Davidson is shown above admiring a paper rolling out of one of the facility's new presses in 1980.

At the time of Davidson's death in 1985, the *News-Journal* newspapers, morning and evening editions, boasted a combined circulation of more than 100,000. (Above, courtesy of the *Daytona Beach News-Journal*; below, courtesy of Halifax Historical Museum.)

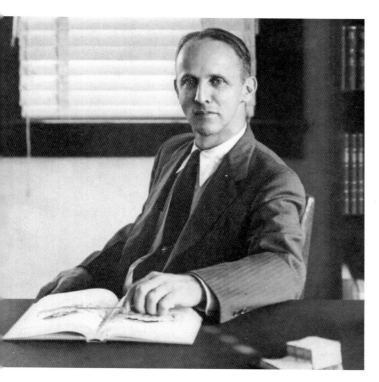

Rubert James Longstreet (1892–1969)

Rubert James Longstreet, longtime educator and supervising principal for all the schools on the Daytona Beach peninsula from 1920 to 1949, was the author of *Birds in Florida*, a standard bird-watching reference published in 1931 and in print through the 1960s. "A little guy with a Napoleonic stance and that sort of eagle gaze, Rubert became a teacher and in time the most outstanding pedagogue in Volusia County," said a memorial editorial in the *Daytona Beach News-Journal*. In 1954, South Peninsula Drive School was renamed R.J. Longstreet Elementary. (Courtesy of Halifax Historical Museum.)

Howard Thurman (1899–1981)

The house where Howard Thurman lived from infancy until he left for high school in Jacksonville is a historic site at 614 Whitehall Street. From those modest beginnings, he would become professor of theology at Morehouse and Spelman Colleges in Atlanta, Georgia, and Howard University and in 1953, dean of Marsh Chapel at Boston University. There, he became a mentor to Martin Luther King Jr. He was author of more than 20 books, including *Jesus and the Disinherited* (1949), which espoused a theology of Christian nonviolent resistance to oppression. (Courtesy of the State Archives of Florida.)

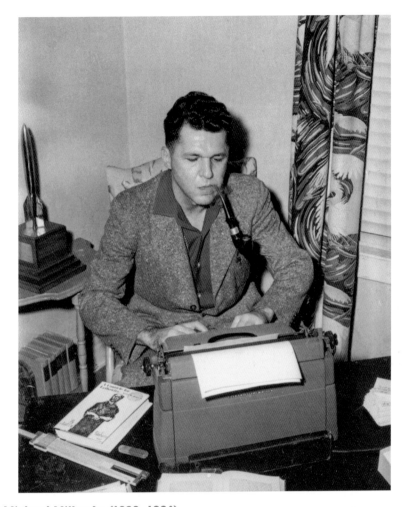

Walter Michael Miller Jr. (1923–1996)

Before dystopian science fiction was a category of young-adult novels, movies, and a standard television plot, there was *A Canticle for Leibowitz* by Walter M. Miller Jr. The Leibowitz in the title is a monk living some 600 years after a nuclear holocaust. His order keeps alive lost knowledge by copying scraps of books they do not even understand. And—spoiler alert—it turns out that mankind learned exactly nothing from almost blowing up the planet.

The book, published in 1959, has never gone out of print and remains hugely influential. It won the Hugo Award for Best Novel in 1961. In this *Daytona Beach News-Journal* photograph taken at his home just as the book came out, Miller looks the very picture of a successful midcentury writer with tweed suit, pipe, and hulking electric typewriter. The rocket ship–shaped Hugo Award seen behind him was for an earlier novelette, *The Darfsteller.*

"He was a very solitary person, a very difficult person," was how one friend described him to the *Daytona Beach News-Journal.* His longtime agent said Miller was the only client he never met in person.

Miller suffered from debilitating writer's block, and soon after *A Canticle for Leibowitz* was published, his output slowed to a trickle. He also remained shaken from his 55 sorties on a bomber crew in Italy in World War II, particularly his part in the bombing of Monte Cassino in 1944. On January 9, 1996, he called 911 and reported a dead person in his yard on Derbyshire Road. Police responded and found him seated in his front yard, dead by single .40-caliber bullet wound to the head. (Courtesy of the *Daytona Beach News-Journal.*)

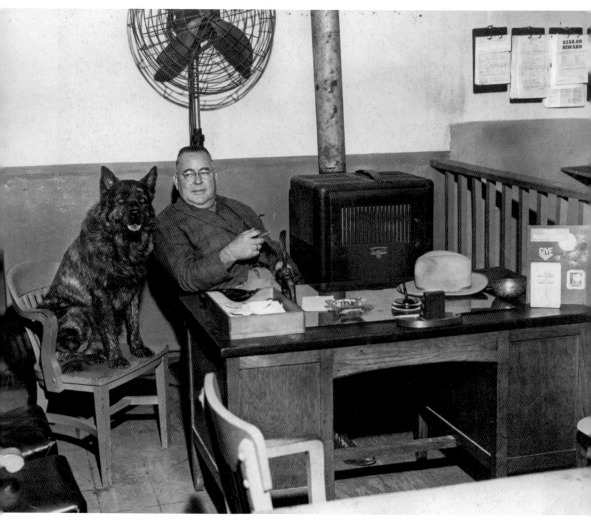

J.C. Beard (1896–1961)

Jefferson Collins Beard, usually called J.C., was a policeman turned justice of the peace who was known for his sense of humor, corrupt practices, compassion, racism, canniness, and ignorance of the law.

He administered his own brand of justice from his Second Avenue courtroom, usually with a shaggy black dog named Pepper by his side at the bench. "You think he's guilty, Pepper?" he would say and listen to the dog's barks. "I think you're innocent," he would say. "But Pepper, here, thinks you're guilty."

Presented with two small-claims litigants who both claimed a bicycle, he made the Solomonic declaration that the bicycle should be cut in half and given to both. On finding a man not guilty of stealing a watch, he pronounced, "I'm finding you not guilty, but you better return that watch within 10 days or you're going to jail."

He was removed from office in 1950 but reinstated. At his hearing, he said he failed to keep required records because he "didn't know the law that well or where to find out." Beard was again removed from office in 1958 for using his post to operate "a bill-collection mill for profit" over his 14 years in the post. He ran for office again in 1960 but was defeated.

"Because of that heart rather than because of his amorality, his friends—and he had hosts of them—will mourn his passing," a *Daytona Beach News-Journal* editorial concluded after his death. "The Daytona Beach scene has lost a bit of its color." (Courtesy of *Daytona Beach News-Journal*.)

Fred Dana Marsh (1872–1961)

Sculptor, painter, illustrator, and muralist Fred Dana Marsh showed up in Volusia in the 1920s and fell in love with the place. With characteristic flair, he had himself flown along the coast in a biplane so he could pick just the right spot for a new home. He chose a beachfront lot in Ormond Beach and built an imposing Streamline Moderne home that locals dubbed the Battleship. "Labor was thirty-five cents an hour, so I plunged in," he later recalled. "The across-the-way golfers [at Oceanside Country Club] wanted to drown me." It would later be the official residence for the president of Embry-Riddle Aeronautical University, but was demolished in 1996.

He is best known locally for the four nude muse sculptures (above) that adorn Peabody Auditorium in Daytona Beach, which have scandalized schoolchildren for more than a half century, and for the statue of Tomokie, a monumentally eccentric depiction of a faux Native American legend that stands in Tomoka State Park. Nearby, the Fred Dana Marsh Museum remains closed due to budget cuts.

Marsh is shown at left at his home with his sculpture *Cactus Girl*. (Above, photograph by Mark Lane; left, courtesy of Halifax Historical Museum.)

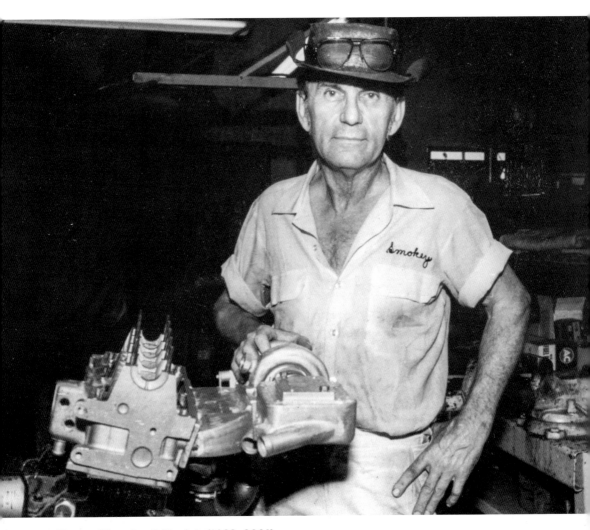

Henry "Smokey" Yunick (1923–2001)

Everyone around Daytona Beach knew Smokey Yunick as the owner of Smokey's Automotive Service, 957 North Beach Street, home of "the best damn garage in town," as its signs, T-shirts, and especially Yunick proclaimed. Everyone else in the world knew him as an innovative, even legendary, racecar designer, mechanic, and owner. Yunick opened the garage in 1948, and inside, during the glory days of the 1960s, he assembled some of NASCAR's winningest cars.

Yunick was an inventor, innovator, master of practical physics, and self-taught man ahead of his time. In addition to his work in racing and mechanics, he wrote a popular monthly question-and-answer column in *Popular Science*, "a clinic on cars by America's most famous mechanic" as the magazine touted it. His black-trimmed Pontiacs twice won the Daytona 500 (1961 and 1962). His cars dominated the first Winston Cup races at Daytona International Speedway and ran in 10 Indianapolis 500s between 1958 and 1975. He also held nine patents.

After a heated argument with Bill France, Yunick announced he had had it with the NASCAR rulebook in 1971 and left stock-car racing for other projects. He died of leukemia in 2001, and his garage was destroyed by a fire in 2011. (Photograph by Roger Simms, courtesy of the *Daytona Beach News-Journal*.)

Marshall Teague (1921–1959)

Marshall Teague, who was born in Daytona Beach and went to Seabreeze High School, was the local fans' favorite driver in the earliest days of NASCAR. That made his death in 1959 at the just-completed Daytona International Speedway a shock that cast a pall over a town that had just been celebrating the track's opening.

Known as the "King of the Beach" for his beach racing, his car, "the fabulous Hudson Hornet," ran in 19 NASCAR races and earned seven victories between 1951 and 1952. His was the first stock-car racing team to be backed by a major automobile manufacturer. He is shown here next to the Hornet with his daughter Patty in 1952.

Teague split with NASCAR after a dispute with Bill France in 1953 but was ready to come back as the new track was being readied for its first races. On February 11, 1959, going for a speed record in an Indianapolis-style car, the car flipped five times and flew apart. Teague died instantly.

Many years later, his daughter told the *News-Journal* of walking into Mainland High School cafeteria that day and how "everyone was talking and listening to their radios when I walked in, and everything went silent." Teague's wife, Mitzi, a widow at 35, was inconsolable and although she would live to be 90, never remarried.

Teague was inducted into the Motorsports Hall of Fame of America in 2014. In the movie *Cars* (2006), the character Doc Hudson, voiced by Paul Newman, was inspired by Teague and his fabulous Hudson Hornet. (Courtesy of the State Archives of Florida.)

Glenn "Fireball" Roberts (1929–1964)

Stock-car racing always had its heroes, but Fireball Roberts was NASCAR's first superstar. Roberts moved to Daytona Beach with his family in 1945 and graduated from Seabreeze High School. Where his famous nickname came from was a point of contention among fans. Was it his high school pitching skills? Epic driving style?

In 1959 and 1960, Roberts won the first two Firecracker 250s (later, the July race would become the 400) and in 1962 won the Daytona 500, one of six he raced in. He won 33 of his lifetime 206 NASCAR Grand National races. Roberts is shown above at the start of his career and below with his trophies and sponsor Frank Strickland in 1958.

Roberts planned to retire from racing in 1964 but on May 24, 1964, he crashed and suffered burns over 75 percent of his body at the World 600 at Charlotte Motor Speedway. He lingered for weeks before dying of pneumonia on July 2, 1964.

A Daytona International Speedway grandstand was named for him the next month. He was inducted into the NASCAR Hall of Fame in 2013. (Above, courtesy of Halifax Historical Museum; below, courtesy of the State Archives of Florida.)

J. Saxton Lloyd (1907–1991)
For all the things J. Saxton Lloyd has done in the community—and they are many—he is probably best known as the person for whom the rectangular manmade lake at the center of Daytona International Speedway is named. As owner of Lloyd Buick-Cadillac, he gave Bill France his first job when he arrived in town. Later, when the Daytona Beach Racing and Recreational Facility District was formed to finance track construction, he headed the group. In 1963, Lloyd formed the Civic League of the Halifax Area to promote community improvement, encourage good government, and respond to community problems. (Courtesy of the *Daytona Beach News-Journal*.)

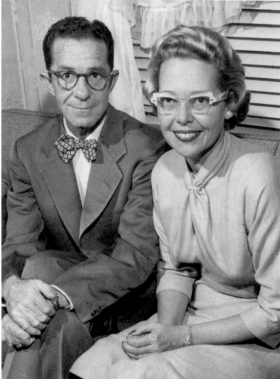

William W. "Billy" Judge (1901–1971)
Billy Judge was both a state attorney and probably the county's most celebrated criminal-defense attorney of his generation. At one time, he was a municipal judge, which gave him the magnificent title Judge William William Judge. (Yes, two Williams.) He is shown here with his wife, Helen, in 1955. (Courtesy of Halifax Historical Museum.)

Mary Brennan Karl (1893–1948)

Mary Brennan Karl started as a business teacher at the Opportunity School, a vocational school for veterans. She became its director in 1937 and expanded its offerings and mission until it became the nucleus for Daytona State College.

The school's courses were offered on several scattered sites. Seeing an opportunity in the military wind-down after World War II, Karl teamed with Mary McLeod Bethune to lobby the War Assets Administration to donate federal land, then used as the Welch Center, an Army convalescent home, to the school system.

This land, the site of the present-day Daytona State College, became home to what soon became the Mary Karl Vocational School. She had always wanted the school to become a full-fledged community college but did not live to see that day. She died at the age of 57.

When Daytona Beach Junior College was established, the Mary Karl Vocational School merged with it. Today, the school's library is called Mary Karl Library and Resource Center. She was inducted into the Florida Women's Hall of Fame in 2011. Her son Fred Karl would become a legislator and Florida Supreme Court justice. (Courtesy of the Florida Commission on the Status of Women.)

James Owen Eubank (1912–2003)

James Owen Eubank's five terms as mayor of Daytona Beach came during the some of the city's most transformative years—1958 to 1969. He served during a time that saw the opening of Daytona International Speedway, the rise of spring break, the end of racial segregation in public facilities, reform of city government, and the arrival and expansion of General Electric Aerospace.

Born in Fulton County, Georgia, Eubank moved to Daytona Beach with his family in 1919. He developed an interest in politics early on and was elected student body president at Mainland Senior High School.

Eubank was elected to the city commission in 1958 and chosen mayor by the commissioners for three terms. After a new charter went into effect in 1965 and the city began choosing mayors by citywide vote, he was elected to the post two more times. Defeated for reelection by Richard Kane in 1969, he was snapped up as an executive at Halifax Hospital, where he remained until he retired in 1983. He is shown here with Kathy Jones in 1970. (Courtesy of the *Daytona Beach News-Journal*.)

A. Oscar Folsom Jr. (1913–2006)

For 33 years, Oscar Folsom was part of Daytona Beach's police force, starting as a patrolman and finishing as public-safety director. He was named police chief in 1958. By 1960, he oversaw a reorganization of the 60-person force and modernized its training and police education. Blunt and no-nonsense, he was known for his political savvy, as he saw city managers and mayors come and go until his retirement in 1978. "This has got to be the hottest seat in the city," he said in 1973, but Folsom loved his work. (Courtesy of the *Daytona Beach News-Journal*.)

Jerome Kermit Coble (1925–2000)

A colorful high-powered attorney, J. Kermit Coble was elected to the Florida House of Representatives in 1964. He is shown here on the floor presenting a painting of Charles Dougherty, speaker of the house from Volusia County, in 1879. But Coble preferred behind-the-scenes work to public office and served only one term. He was a skilled fundraiser, formidable power broker, and at times boisterous advocate for his clients. (Courtesy of the State Archives of Florida.)

Don J. Emery (1888–1956), Don W. Emery (1924–1992)

Father and son, the Don Emerys depicted almost three-quarters of a century of Volusia County life in their murals, paintings, and drawings. The father arrived in the 1920s, and the son was born here.

The elder Emery's most visible work was the design for the Tarragona Tower, built in 1926 as the imposing gateway to Highlands Estates. Both father and son worked together in 1947 on the Florida history murals that adorned Merchants Bank on Beach Street, now the Halifax Historical Museum, where they can still be seen. The younger was known for his portraits and landscapes. "I dutifully tried to be an abstractionist. It just never took," he said. He was also a member of the Daytona Beach Planning Board for close to 25 years. He had "an appreciation for the aesthetic as well as the practical side of city planning," a *News-Journal* editorial said.

The younger Emery is shown here sketching a portrait of educator Mary Karl. Several of the Emerys' paintings are part of the collection of the Cici and Hyatt Brown Museum of Art. (Courtesy of Halifax Historical Museum.)

Tom Wetherell (1912–1996)
Son of an area pioneer family, Thomas Wetherell was an executive for Sears, Roebuck and Co. starting in 1934, when Sears was on Beach Street downtown. Father of former Florida State University president T.K. Wetherell, he was president of the chamber of commerce in 1962 and instrumental in luring Embry-Riddle Aeronautical University to Daytona Beach from Miami. "He was one of a group of people who passed through Daytona Beach and made it a better place," said Bill France Jr. (Courtesy of the *Daytona Beach News-Journal*.)

J. Hart Long

Dentist J. Hart Long won an election without his name being on the ballot because he had more than 700 write-in votes. His fellow commissioners voted him mayor in 1957. Two years later, Long had had it with politics. "I'd pray I'd lose because I didn't want to quit," he later said. His prayers were answered when he lost by 30 votes. He left politics but remained active in the community, so much so that in 1992 he was awarded the J. Saxton Lloyd Community Service Award by the civic league. (Courtesy of the *Daytona Beach News-Journal.*)

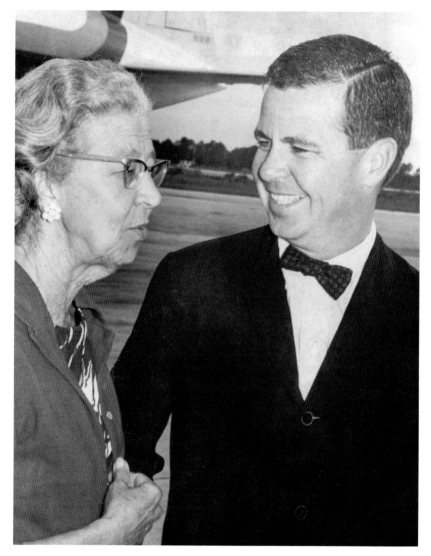

Daniel Perkins Smith "Dan" Paul (1924–2010)

Famed First Amendment and environmental attorney Dan Paul was born in Jacksonville but grew up in Daytona Beach. He was the son of Henry Paul, a pharmacist, and Cornelia Smith Paul, Volusia County's tax collector. He remained a frequent visitor through his life and is pictured here with his mother in 1966.

In the 1970s, Paul was the attorney for the *Miami Herald* and successfully argued the newspaper's side in Miami Herald Publishing Company v. Tornillo, which struck down state right-to-reply laws. The court ruled that the First Amendment did not allow the government to tell a newspaper what to print.

Paul represented the National Audubon Society in the 1960s fight to stop a proposed Everglades jetport. He's been called "the father of Metro" for his work in producing Miami-Dade's charter.

"Though he never sought public office, Paul was among the most influential players in modern county history," a *Miami Herald* memorial editorial said. "Famously witty and acerbic, he was the scourge of pompous politicians and rapacious land grabbers—and called himself a 'public scold.' "

The John F. Kennedy School of Government at Harvard University set up the Daniel Paul Professorship in 2001. Paul is buried in Edgewater. (Courtesy of the *Daytona Beach News-Journal*.)

Richard V. Moore (1906–1994)

The third president of Bethune-Cookman College, from 1947 to 1975, Richard V. Moore oversaw an expanding institution that tripled enrollment, diversified its offerings, and received full accreditation. In 1947, college founder Mary McLeod Bethune used her formidable powers of persuasion to convince Moore, then in a secure job in Tallahassee as the first black state supervisor of the segregated secondary school system for black students, to come to the small college that had only five buildings and 400 students.

"There were no sidewalks, street lights or landscaping and some of the academic buildings were frame government surplus," he recalled. "There was a lot of hard work ahead."

As chairman of the city's interracial advisory board, Moore helped see his community through the breakup of racial segregation. During the 1960s, according to his wife, Beauford J. Moore (1914–2010), the couple's house was once cordoned off by the FBI because of death threats. "He was threatened many times, and he helped keep our town safe," she said at his funeral.

He was a member of the Daytona Beach Planning Board from 1957 to 1973 and the first black person appointed to Halifax Hospital's board. On his retirement from the college, he received a standing ovation from the Florida House of Representatives as it passed a resolution honoring his career. When it was time to name the community center on Mary McLeod Bethune Boulevard, the Richard V. Moore Center was the obvious choice. Like Bethune, Moore was buried on campus. (Courtesy of the *Daytona Beach News-Journal*.)

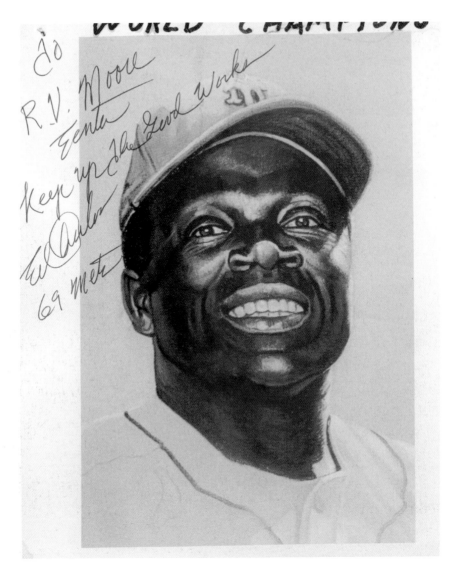

Edwin Douglas "Ed" Charles

Toward the end of *42*, the 2013 movie about Jackie Robinson's breaking the color line in professional baseball, a little boy is seen with his head to the rails listening to the last sounds of Robinson's train pulling out of Daytona Beach. That boy, viewers are told, was Ed Charles, and he would grow up to win the World Series as a player for the 1969 Miracle Mets. In interviews since then, he says yes, he and his friends were really at the train station and did that. "We wanted to be a part of him as long as we could," he told a Robinson biographer.

Born in Daytona Beach in 1933, Charles grew up one of nine children in an impoverished home. He could not afford a ticket to the game but watched through the fence as Robinson played his historic game on City Island. But he said he was too in awe of Robinson to approach him.

Charles left Daytona Beach around the time he was in eighth grade. By 1952, he had signed with the Quebec City Braves, a minor-league team. He played in the Major Leagues for eight years for the Kansas City Athletics and New York Mets. Known as the "Glider" for his graceful base running and diving catches, the third baseman boasted 86 home runs and a .263 batting average. He was also known for his poetry. Charles retired from the majors in 1969. (Courtesy of the *Daytona Beach News-Journal*.)

Harry Wendelstedt (1938–2012)

Harry Wendelstedt had a 33-year career with National League baseball and was umpire for five World Series and seven National League Championship Series. He came to umpiring after attending the Al Somers School for Umpires in Daytona Beach in 1962. He later taught at the school and took it over after Somers retired in 1977. The school moved to Ormond Beach in 1990, where it still operates.

"Over six feet and burly, Wendelstedt was also one of the game's most unassailable on-field authorities," is how he was described in his *New York Times* obituary. Wendelstedt is shown here in 1982 officiating at a local Special Olympics game, one of many local sports where he volunteered. He died of complications from a brain tumor in 2012. His son Hunter Wendelstedt is also a Major League umpire—he wears the number 21, the same as his father—and continues to operate the Harry Wendelstedt Umpire School in Ormond Beach. (Photograph by Charles Harn, courtesy of the *Daytona Beach News-Journal*.)

George W. Engram (1913–1998)

Mary McLeod Bethune convinced George Engram to move to Daytona Beach in 1933 to become the projectionist at the Second Avenue Ritz Theater. But despite a degree in electrical engineering from Tuskegee Institute, he was denied a projectionist's license because of his race. Engram stayed in town anyway, taught applied electrical science at Bethune-Cookman College, and became the first black person in Florida to pass the state electrical-contractor exam. He later founded Engram Electric, the first black-owned electrical company in the area.

Engram ran for Daytona Beach City Commission but lost in a runoff in 1948, the first black person to seek city office since 1900, when Joseph Brook Hankerson had been elected to a second term on the Daytona City Council. He ran again unsuccessfully in 1960.

Frustrated at the way black people were kept off the beach in Daytona Beach in the 1940s, he became a major investor in Bethune-Volusia Beach, a beach south of Daytona Beach for black vacationers. "Every summer, busloads of black people came to Bethune Beach. It seemed like, to me, we were perpetuating segregation, but it was the only way we get it," he recalled. He is shown here on Bethune Beach at far right with Bethune, second from left.

In 1996, at 83, Engram was chosen to help carry the Olympic torch through town; by then he was in a wheelchair and was pushed by his son. Shortly before his death in 1998, part of Fairview Avenue was renamed George W. Engram Boulevard. And Engram Road still runs through Bethune Beach, one of the few reminders of its days as a black resort. (Courtesy of the *Daytona Beach News-Journal*.)

Mabel Norris Chesley (1914–1995)

Mabel Norris Chesley was a journalist and co-owner of the *Mount Dora Topic* whose writing fell afoul of powerful Lake County sheriff Willis McCall. She stood up to death threats—a grenade was thrown at her house, her dog was poisoned, dead fish were dumped on her lawn, and a cross was burned in her yard. Chesley left Lake County in 1958 for the friendlier environs of Daytona Beach. (Her time in that period is described in the Pulitzer Prize–winning history *Devil in the Grove*. A movie is also in development.) She was a columnist and editorial writer for the *News-Journal* until 1977.

She wrote extensively about the civil-rights movement and interviewed Martin Luther King Jr. during the St. Augustine demonstrations of 1964. Chesley is shown here in 1975 when she was awarded the Martin Luther King Jr. Award from Bethune-Cookman College for outstanding community service in civil rights. (Courtesy of the *Daytona Beach News-Journal*.)

The Nightcrawlers (1964–1970)

The Nightcrawlers were a Daytona Beach garage band that had one hit on regional radio, "Little Black Egg." The song only reached No. 85 on the Billboard singles chart in 1967, but it was ubiquitous on local AM radio for a decade and remains a garage-band standard. It has been covered by the Lemonheads, the Cars, Tarnation, and other bands. In 2009, a documentary on the song, *Cracking the Egg: The Untold Story of The Nightcrawlers*, was released.

With a simple, hypnotic guitar intro and nonsense lyrics ("I won't let them won't let them stretch their necks / To see my little black egg with the little white specks") it is instantly recognizable. The song was composed for a 1965 concert when the band opened for the Beach Boys.

Several people played with the Nightcrawlers, but its core was Charlie Conlon, Rob Rouse, Sylvan Wells, Tommy Ruger, and Pete Thomason. Wells went on to practice law. Ruger would later play drums for Root Boy Slim and the Sex Change Band. He died in 2013. Record store owner Michael Toole is pictured here with the group's collectible album. (Courtesy of *Daytona Beach News-Journal*.)

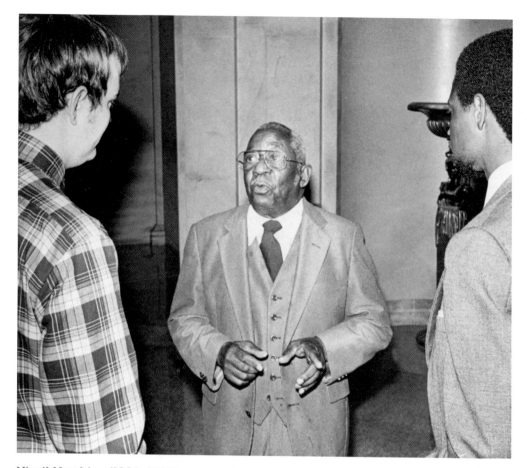

Virgil Hawkins (1906–1988)

In 1949, Virgil Hawkins, a graduate of Bethune-Cookman College and the school's public-relations director, did the unthinkable: he applied for law school. He applied to the all-white University of Florida and set off nine years of legal challenges.

At first, the Florida Supreme Court required Florida to build a law school for black students at Florida A&M University, but in 1956 the US Supreme Court overruled that and ordered him admitted. The state supreme court still resisted but allowed he might be admitted when "his admission can be accomplished without doing great public mischief." In 1957, it looked like a long way off.

Hawkins left Daytona Beach for Boston and graduated from New England College of Law in Boston in 1964. Still, he found himself barred from taking the state bar exam because the college was not yet accredited. It was not until 1976 that the Florida Supreme Court ordered him admitted as an attorney.

But that was not where the story ended. In his 70s and in poor health, he had trouble running a one-man law office that served thousands of clients, often for little or no charge. Clients complained about mistakes, and he was found to have illegally used trust funds, was charged with grand theft, and ultimately disbarred. He is shown here with supporters in 1983. He closed his Leesburg office in 1985 and died three years later.

But Hawkins's tenacity is what people remember, and shortly after his death he was posthumously reinstated in the bar. At a ceremony in 1999, the Florida Supreme Court apologized to Hawkins for its treatment of his case. And at the University of Florida, the Virgil D. Hawkins Civil Clinics program gives students experience in family law. (Courtesy of the State Archives of Florida.)

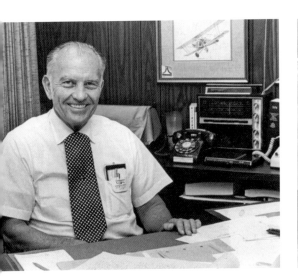

Jack R. Hunt (1918–1984)

Jack Hunt was president of Embry-Riddle Aeronautical University from 1963 until his death in 1984. During that time, he took it from a 239-student school running out of what one reporter described as "a crummy old hotel in Miami" to a modern, accredited 5,000-student aeronautical and aerospace university. During that time, the university acquired another campus in Prescott, Arizona, and started its international program, which now operates in 125 locations.

In April 1965, the institution moved from Miami to Daytona Beach. This was a volunteer effort with a convoy of 27 donated trucks and more than 30 local volunteers packing up the 50 tons of school materials and driving them 260 miles to Embry-Riddle's new home. Although the school had been in talks with Ormond Beach, Hunt persuaded Daytona Beach to sell the aeronautical institute (it did not yet call itself a university) 85 acres of airport land, which sealed the deal.

Hunt is shown at left in his office in 1976. Also pictured is the school's Wright brothers sculpture by Larry Godwin being hoisted into place in front of the Jack R. Hunt Memorial Library in 1990. (Both, courtesy of the *Daytona Beach News-Journal*.)

CHAPTER FOUR

Nowadays
1976–Present

The year Daytona Beach celebrated its centennial, the city's population was approaching 50,000. A new city hall had just been built on Ridgewood Avenue. And about 125,000 fans, plus 18 million *Wide World of Sports* viewers thrilled to a spin-out involving Richard Petty and David Pearson that saw Pearson limp across the finish line to win the Daytona 500. Daytona Beach had come a long way from the sleepy riverfront village that Matthias Day founded.

The city had matured politically and enjoyed a period of exceptionally stable political leadership under city manager Howard Tipton, who served from 1978 to 1994, and Mayor Larry Kelly, who served from 1974 to 1993. County government had modernized too, when on June 30, 1970, voters approved a county charter that took effect the next year. Volusia County was the first county in Florida to enact a home-rule charter, and most populous counties in the state would soon follow suit. In 1986, the charter was amended to bring the beaches in Daytona Beach and the rest of the county under unified county management.

A new attempt to unify the cities around the Halifax River failed decisively in 1985 with 55 percent of voters opposing consolidation and 45 percent supporting. The plan would have united Daytona Beach, Ormond Beach, Port Orange, Daytona Beach Shores, Holly Hill, South Daytona, Ponce Inlet, and some unincorporated land into one large city, the fifth-largest in the state. But the only cities voting for consolidation were Daytona Beach and Daytona Beach Shores. By the 1980s, each area city had developed its own politics and identity, formed at least in part from the ways it differed from Daytona Beach, and few wanted to give that up.

In the 1980s, spring break and bike week had grown dramatically. Spring break flourished dramatically after the cable-television channel MTV started broadcasting live from the boardwalk on March 21, 1986. The number of revelers immediately shot up. The number probably peaked during 1989, when an estimated 400,000 breakers descended on the town.

The traffic gridlock, arrests, destruction of property, and public drunkenness caused a political backlash against the event. Police presence was ramped up, and bar hours were dialed back to 2:00 a.m. Most significantly, the city disinvited MTV from filming on public property, prompting MTV to move the show to California in 1994. But by then, the spring-break market had already fragmented, with dozens of new destinations for students to choose from.

In recent years, the city has been marketing itself as more of a year-round tourist destination, the kind of place with a state college and two universities that would be inviting to new businesses even if one did not count the climate, beach, and quality of life that have drawn people here since Day first talked up the area to his Ohio neighbors and family.

A civic milestone was passed in 2003 when Yvonne Scarlett-Golden was elected the first black mayor of Daytona Beach. She was also the first popularly elected woman mayor. (Josie Rogers, a city commissioner for the town of Daytona, had been voted mayor by the other commissioners in 1922.) The retired educator was reelected in 2005 and died in office in 2006.

In 2004, the Daytona Beach area, which had not had a serious hurricane since Hurricane Donna in 1960, experienced three hurricanes within a six-week period, Hurricanes Charley, Frances, and Jeanne.

And then Hurricane Ivan, although well away from the area, brought heavy rains to Daytona Beach. Volusia County sustained $560 million in damage. Daytona Beach's beachfront was particularly hard hit, with hotels and condominiums destroyed, abandoned, and in need of extensive repair and rebuilding.

First the hurricanes and then the economic shock from the Great Recession and collapse of the 2006–2007 housing bubble brought the city its first population loss since its founding. Since then, the city has bounced back with new construction on the beachside, expansion of Daytona International Speedway, and renewed year-round tourism and commercial investment.

Daytona Beach Mayors (1940–1993)
In 1978, all the living mayors of Daytona Beach lined up for a group photograph in front of city hall. They are, from left to right, Larry Kelly, Olli Lancaster, John Tamm, Ucal Cunningham, W.C. Perry, Richard Kane, Dr. J. Hart Long, and J. Owen Eubank. (Courtesy of *Daytona Beach News-Journal.*)

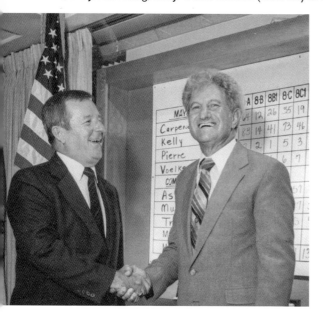

Lawrence J. "Larry" Kelly
Larry Kelly (left) was Daytona Beach's mayor from 1974 to 1993, serving 12 consecutive terms. He was the winningest mayor in the city's history. The General Electric engineer also served as city commissioner from 1971 to 1974. He was in office during a time of rapid population growth that also saw the rise and fall of spring break. Larry Kelly Field at Municipal Stadium was named for him in 1994. He is shown here congratulating Bud Asher in 1989. (Courtesy of *Daytona Beach News-Journal.*)

William Clifton France (1933–2007) (OPPOSITE PAGE)
Bill France founded NASCAR and Daytona International Speedway. His son Bill France Jr. (technically, he was not a junior, but everyone called him that) took them national and brought them into the big time. One was the mythic founding figure, the other was the man who organized stock-car racing into a multibillion-dollar national sport.

The younger France grew up around racing—everything about the business. There is no aspect of holding a race that he did not have a hand in as a young man. During the beach-racing era, he stapled posters on power poles, worked the ticket booth, and was a scorer, flagman, starter car inspector, and post-hole digger. He put up the signs that warned "beware of rattlesnakes" to deter spectators from sneaking in through the palmetto scrub for free looks. As the speedway was being built, he even worked a road grader.

In 1972, the elder France turned NASCAR over to Bill France Jr. In 1981, the younger France was named chief operating officer of International Speedway Corporation. Both father and son have often been described as benevolent dictators of the sport. The "benevolent" modifier was often dropped for the father, less so with the son. He is shown here talking with race driver A.J. Foyt in 1982.

France oversaw a time of astounding growth. When he stepped down as NASCAR and the International Speedway Corporation's chief executive officer in 2003, NASCAR was second only to football in television ratings. The year before that, 17 of the Top 20 most highly attended sporting events were Winston Cup races.

He died at home in 2007 knowing he brought things a long way from the days of rattlesnake signs and beach racing and laid the groundwork for much more to come. (Photograph by Pam Lockeby, courtesy of the *Daytona Beach News-Journal*.)

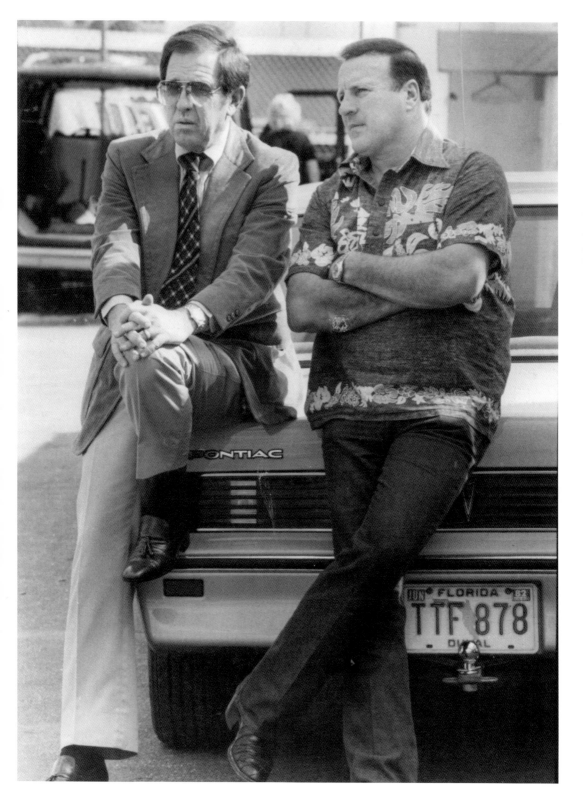

Howard Tipton

Howard Tipton (left) was Daytona Beach's city manager for nearly 16 years. During that time, Daytona Beach more than doubled in acreage, and the population grew by almost a quarter. Arriving in 1978, he organized, streamlined, and generally shook up city government. Redevelopment efforts were launched in the Main Street, downtown, and midtown sections of town, and projects such as the Halifax Harbor, the Daytona Beach Marriott, and Ladies Professional Golf Association headquarters got under way.

Soon after a tense 4-3 vote of confidence by the city commission, Tipton was snapped up by Orlando in 1994 as that city's chief administrative officer, a post he held until 2000. Called the "dean of city managers" for his 50 years in the profession, he received the Florida League of Cities' first Raymond C. Sittig Distinguished Public Service Award. "Florida is a better state for his service, and our cities are better for his service," said league president P.C. Wu. (Courtesy of the *Daytona Beach News-Journal*.)

Fred Karl (1924–2013)

Fred Karl had a resume that looks like a mash-up from four different people. He was a state senator and representative from Daytona Beach. He was also a state supreme court justice, Hillsborough County's administrator, a hospital chief executive officer, city attorney, county attorney, and, on top of that, a World War II tank-platoon leader when still a teenager.

Karl was born in Daytona Beach in 1924, the son of Fred and Mary Karl. His father was a Michigan businessman who was wiped out in the Great Depression. His mother founded the Mary Karl Vocational School, which would later evolve into Daytona State College.

Karl ran for governor in 1964, losing a six-way Democratic primary to Haydon Burns. He is pictured here second from right holding a plate of barbecue at a campaign event.

He served in the state senate from 1968 to 1972, representing a district that stretched from Volusia to Citrus County. Soon after his election, he introduced legislation that led to the drafting of Volusia County's charter, making it the first Florida county to modernize its government through a charter reorganization.

"You could call him the father of Volusia as we know it today," said his colleague in the legislature, Sam Bell. "He had a way of getting people to be less emotional . . . and move them toward solutions," recalled former speaker J. Hyatt Brown. (Courtesy of the State Archives of Florida.)

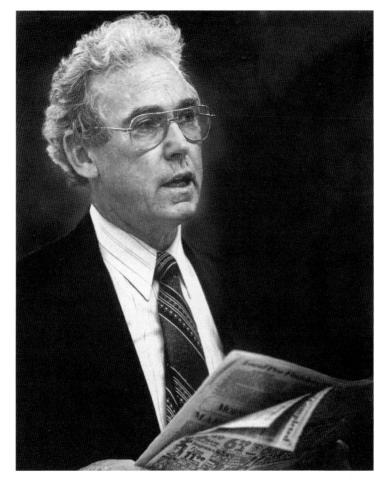

Dan Warren (1925–2011)

Criminal defense attorney Dan R. Warren was known as a spellbinding courtroom orator. He was a civic leader and crusading state attorney who found himself caught up in the civil-rights fights of the 1960s.

As a prosecutor and special counsel to Gov. Farris Bryant in 1964, Warren worked as a negotiator between state officials and Martin Luther King Jr., trying to defuse an explosive reaction to desegregation in St. Augustine. He recounted the events of that year in the book, *If It Takes All Summer* (2008).

During that summer of racial tension, Warren ordered the beaches desegregated and prosecuted the Klan. These efforts earned him the hatred of St. Augustine officials who were fighting desegregation and brought death threats from the Klan. "We're proud of Dan Warren," ran the headline of a *Daytona Beach News-Journal* editorial that July.

He was elected to the Daytona Beach City Commission in 1952 as a reform candidate and was one of the original members of the Daytona Beach Speedway Authority. Warren served on that body for 46 years and worked closely with Bill France to raise funds to build Daytona International Speedway.

The son of a letter carrier in Concord, North Carolina, he left high school at 17 to join the Army Air Corps in World War II and was a nose gunner on a B-24 bomber in Italy. On his return, he finished high school and enrolled at Guilford College in Greensboro, North Carolina, but left before his senior year to attend Stetson University College of Law.

Warren was named justice of the peace in 1958 and hired as an assistant state attorney in 1962. He was appointed state attorney in 1963 and elected to that position after a hard-fought election in 1964. (Photograph by Pam Lockeby, courtesy of the *Daytona Beach News-Journal*.)

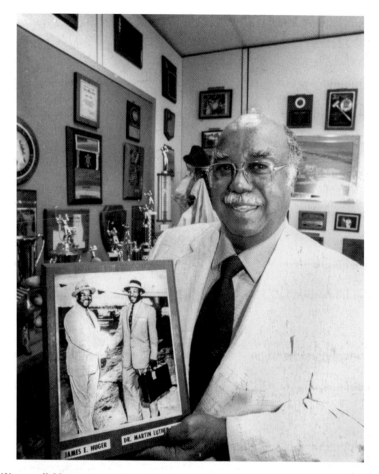

James E. "Jimmy" Huger

Jimmy Huger was Volusia's first black county councilmember, serving three terms. He was also the first black city commissioner elected in Daytona Beach in modern times. (That last modifier is needed because Joseph Brook Hankerson, a black minister, was elected to Daytona's City Council in 1898 and reelected in 1900.) Huger served three terms as commissioner, stepping down in 1971 to run unsuccessfully for mayor.

Huger was born in Tampa in 1915 but came to Daytona Beach in his early teens. He attended Bethune-Cookman College when it still included a high school and junior high, but dropped out. The college's formidable president, Mary McLeod Bethune, tracked him down to the hotel where he worked and told him she arranged to have him replaced and informed him he was to immediately return to the college. He would eventually get a master's degree at the University of Michigan and come back to teach at Bethune-Cookman.

He was also in the first group of black volunteers to serve in the US Marine Corps, with 20,000 Marines who trained from 1942 to 1949 at a segregated training camp at Montford Point, North Carolina. He advanced to the rank of sergeant major. In 2012, at the age of 97, he was among 400 surviving Montford Marines in Washington to be presented with the Congressional Gold Medal, the nation's highest civilian award.

He is shown here holding a photograph taken in 1958 when he welcomed Martin Luther King Jr. after the civil-rights leader stepped off a plane at Daytona Beach Regional Airport on his way to address Bethune-Cookman College graduates. (Photograph by Pam Lockeby, courtesy of the *Daytona Beach News-Journal*.)

Robert J. "Desi" Desiderio (1927–2009)

Robert Desiderio, shown here at his desk at the *Daytona Beach News-Journal* in 1981, was known simply as Desi to a half-century of readers.

He wrote the city hall beat column from 1963 to 1985, in which he chronicled the doings of three mayors, five city managers, and 11 city commissions, and was called "the eighth commissioner" for his authoritative knowledge of all aspects of city politics, planning, history, and governance. He went on to write the popular question-and-answer column *Dear Desi* for another 17 years.

In the days before the Internet, when there were only two television stations, Daytonans could turn to Desiderio. His columns and coverage were the point from which local political discussion tended to begin. (Photograph by Mark Lane.)

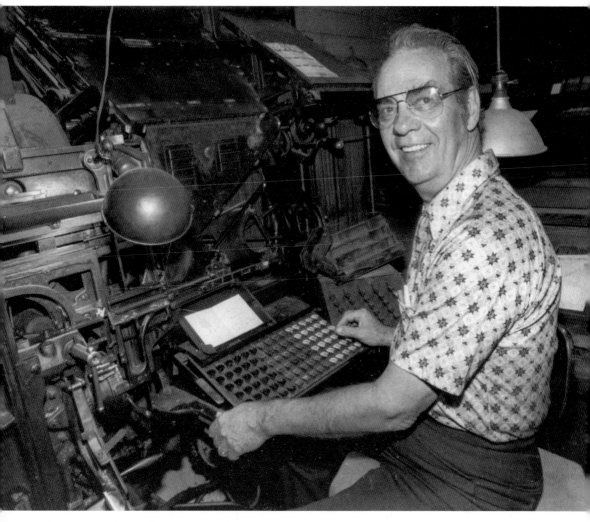

Donald M. "Don" Burgman (1924–1999)

Don Burgman, shown here at the keyboard of his print shop's Linotype machine, was a printer, city commissioner, local historian, and third-generation Daytonan. His father, Jerome Burgman, was credited with coining Daytona Beach's slogan, "The World's Most Famous Beach," and his grandfather printed books and newspapers for Helen Wilmans Post.

Born in Seabreeze, Burgman served in the Army Air Corps in World War II and returned home to work at the family business, Burgman Printing. His interest in urban planning led him to seek a seat on the Daytona Beach Planning Board, where he served from 1972 to 1985. There, he was an advocate for beautification and upgrading city building standards. Appointed to the city commission to complete the term of a commissioner who stepped down, he served from 1984 to 1991. (Photograph by W. Dennis Winn, courtesy of the *Daytona Beach News-Journal*.)

Baron Henry "Bud" Asher (1925–2013)

Bud Asher was mayor from 1995 to 2003 and had been reelected in 1997 by a better than 4-1 margin. Before that, he had been a Daytona Beach city commissioner from 1983 to 1995. In an era of smooth, cautious candidates who seldom ventured beyond their comfort zones, Asher was decidedly old-school, an outspoken, hands-on, out-in-the-crowd, retail politician with a big penumbra of white hair recognized in all neighborhoods in all parts of town. There was no civic group too small, no niche group too minor, that he did not talk up and chow down with the membership, then pose for a plaque-passing photograph before heading to the next event. He is shown here campaigning by the roadside.

Asher also was an attorney, a New Smyrna Beach municipal judge, a hotel and nightclub owner, and an unabashed promoter for the city and spring break, but he was particularly remembered for his work with young people as a football coach. At various times he coached for Stetson University, Bethune-Cookman University, and Mainland, New Smyrna Beach, and Spruce Creek High Schools as well as the semiprofessional Daytona Beach Thunderbirds and the professional Jacksonville Sharks of the short-lived World Football League. (Photograph by John Gontner, courtesy of the *Daytona Beach News-Journal*.)

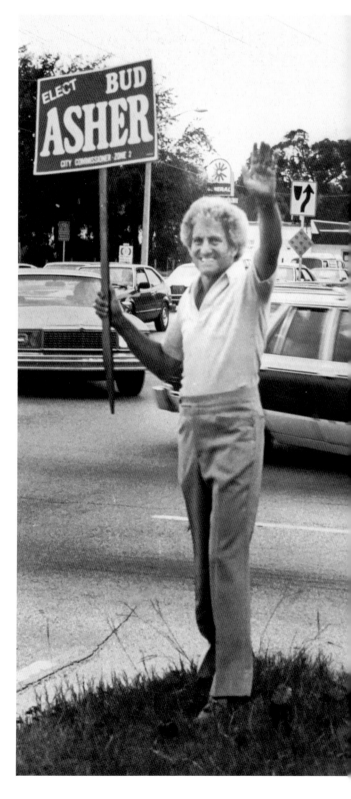

Bob Ross (1942–1995)

Television painting instructor Bob Ross is probably most famous, or at least the most globally recognized, native Daytonan. His PBS how-to show *The Joy of Painting* ran from 1983 until 1994, and there are 403 episodes in all. It was immensely popular, seen by millions around the world, and continued in reruns long after his death. Even non-painters responded to his calming voice as he encouraged would-be painters with advice like, "We don't make mistakes; we just have happy accidents." Google featured his likeness on its homepage on October 29, 2012, what would have been his 70th birthday. The only other Daytonan so recognized was Mary McLeod Bethune.

Ross was born in Daytona Beach in 1942 to Jack and Ollie Ross. He went to Orlando High School and joined the Air Force while still a teenager. It was while stationed in Alaska that he first took up painting. Ross estimated that he turned out some 30,000 paintings before his death from lymphoma in New Smyrna Beach in 1995. (Courtesy of Bob Ross Inc.)

Duane Allman (1946–1971)

Duane Allman is Daytona Beach's rock legend. His family arrived here around 1959. He went to Seabreeze High School and played with bands such as the Kings, the Uniques, the Escorts, and the Allman Joys before dropping out of high school. In a career that barely lasted a decade, he was a studio player for the greatest names in rock and rhythm and blues and propelled the Allman Brothers Band to greatness. He died in a motorcycle accident at age 24. He is pictured here in 1969. (Courtesy of the *Daytona Beach News-Journal*.)

Gregg Allman

Duane Allman's brother Gregg is Daytona Beach's biggest rock star. He wrote about his Daytona days playing with his brother in the first chapters of his bestselling 2012 memoir, *My Cross to Bear*. He writes affectionately of his early days here but reluctantly concludes he had to stay away from town: "Daytona wasn't too good for me in terms of drugs and alcohol." He is shown here at a 1991 Daytona Beach concert. (Courtesy of the *Daytona Beach News-Journal*.)

Hal Marchman (1919–2009)

Hal Marchman was nationally famous for leading the prayer before races at Daytona International Speedway, something he did beginning with the first Daytona 500 in 1959. He was known for ending prayers with the ecumenical signoff "Shalom and amen!" He once famously closed his prayer with "signed Bill France," to emphasize to the deity where these requests were coming from.

The former pastor of Central Baptist Church, he was cofounder of Stewart Treatment Center in Daytona Beach in 1971. His work fighting addiction grew out of his struggles with alcoholism. "Hal knew what it was like to fight alcoholism. It made him a special person. You can't have a testimony if you don't have a test. Hal had been tested and he had passed," said NASCAR driver Darrell Waltrip.

The Georgia native moved to Daytona Beach with his wife, Mary, after World War II to run a downtown grocery store. Marchman, who had developed a drinking problem as a soldier, began attending Alcoholics Anonymous and that led to his joining Central Baptist Church. He soon felt called to ministry. The Marchmans sold the store and both enrolled at Stetson University. He went on to Southern Baptist Theological Seminary and in 1959 returned to Central Baptist as its pastor. That was also the year France asked him to deliver the invocation before the Daytona 500, something he would do every year through 2004.

He retired from his post at Central Baptist in 1997 and in 1989 became a legislative lobbyist for the Volusia County School Board. When the legislature passed a law in 1993 covering commitment and treatment of substance abusers, it was named the Hal S. Marchman Alcohol and Other Drug Services Act. (Courtesy of the *Daytona Beach News-Journal*.)

Gaulden Reed (1918–2007)

Gaulden Reed was a fisherman extraordinaire, builder, beach activist, sailor, and surfing pioneer. A native Daytonan, he began surfing in the 1930s, paddling out homemade 14- and 16-foot plywood long boards with mahogany noses. (Some of his boards are on display at the Halifax Historical Museum.)

Reed built hundreds of seawalls and the Ormond Beach Pier, which he operated for a time. Never far from the water, he was a beach concessionaire for many years, renting inflatable floats. People in Daytona Beach, he said, "should take their bathing suits to work and take advantage of what we have" on their way home. He was passionate about a free beach and beach driving and unsuccessfully ran for Daytona Beach mayor on those issues in 1985. He died of cancer in 2007. Characteristically, he instructed that his ashes be scattered on the beach he loved. (Courtesy of Halifax Historical Museum.)

Chapman S. Root (1925–1990)
Chapman S. Root (left) was the grandson of the industrialist who oversaw the design of the iconic Coca-Cola bottle in 1915, and he was chairman of the country's largest Coca-Cola bottling company and a celebrated racecar owner. He is seen here with his wife, Susan, and Bill France. In 1982, Root sold his majority interest in Associated Coca-Cola Bottlers for a reported $417.5 million, catapulting him into the *Forbes* list of richest Americans. At the time of his death in 1990 in Ormond Beach, Root Company had extensive land investments, owned the Daytona Beach Hilton Hotel, and managed radio stations, including WNDB AM–1150 and WDNJ-FM. (Courtesy of the *Daytona Beach News-Journal.*)

Harold Cardwell (1926–2012)
Harold Cardwell lost his sight at age 40 yet was a prolific writer with an in-depth knowledge of the Halifax area. He wrote 13 books, including *Historic Photos of Daytona Beach, Daytona Beach: 100 Years of Racing,* and *Remembering Daytona Beach.* People wondered how he did it. "He had a photographic memory, or rather an audiographic memory," said Halifax Historical Museum director Fayn LeVeille. "He could remember everything." Before becoming blind, he was a landscape architect. Afterward, he worked as a horticulture therapist and coordinator at the Rehabilitation Center for the Blind. (Courtesy of Halifax Historical Museum.)

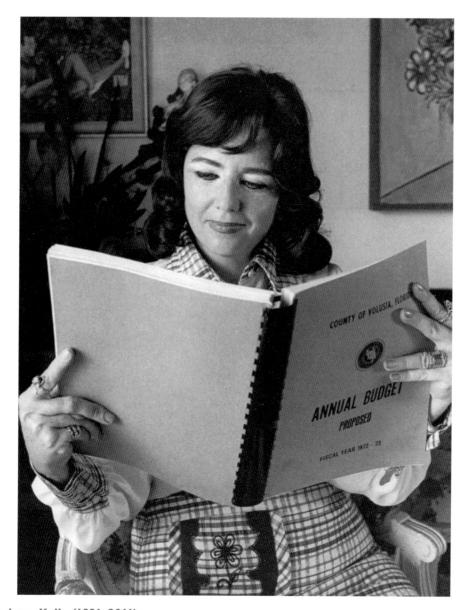

Barbara Kelly (1931–2011)

In 1972, Barbara Kelly was the first woman elected to the Volusia County Council. She served one term representing District 4 before running unsuccessfully for the Florida House of Representatives. She was a supporter of the county's new charter and a particularly strong voice on beach, environmental, and planning issues, where she was often ahead of her time though on the losing side in council votes.

Married at 16 to Roger Kelly, the couple moved here and lived on the beach. Despite the pressures of raising four children—and the inconvenience of never having learned to drive a car—she served on the South Peninsula Zoning Board, was a leader in civic organizations, and ran unsuccessfully for mayor of Daytona Beach Shores in 1964.

The same year she was elected to the county council, she also opened Barbara's Blouse House, a landmark on Seabreeze Boulevard until it closed in 1996. She died at home in her sleep in 2011. (Photograph by Bob Pesce, courtesy of the *Daytona Beach News-Journal*.)

Herbert Marc "Tippen" Davidson Jr. (1925–2007) and Josephine Field "Jo" Davidson (1921–1995)

Tippen and Jo Davidson were the third generation of the family that owned the *News-Journal*, from 1928 to 2009. They are shown here in 1986 admiring the first copies of the combined *Daytona Beach News-Journal* as they roll off the press. Previously, the company had published a separate *Morning Journal* and *Evening News*.

Tippen Davidson was a classically trained musician who attended the Juilliard School of Music in New York but came home to work as a *News-Journal* reporter in 1947. In 1962, he was appointed vice president and general manager. He assumed the roles of president, publisher, and coeditor after the death of his father in 1985.

The former Josephine Field came to the paper in 1945 after seeing a classified advertisement touting an opening for a reporter, and married Davidson in 1947. She was coeditor in 1985 and then editor of the *News-Journal*.

Their support for the arts was legendary. They saw them not only as important in themselves but also as a force for good in the community and a way to improve the town's sagging image. They brought the London Symphony Orchestra to Daytona Beach starting in 1966 and founded Seaside Music Theater. They also started and oversaw the newspaper's Medallions of Excellence award, which continues to recognize the best of the area's graduating high school seniors. (Courtesy of the *Daytona Beach News-Journal*.)

J. Hyatt Brown

Hyatt Brown's speakership in the Florida House of Representatives was the high point of a period that writer Martin Dyckman called "the golden age of Florida politics." It was a heady time when a group of younger, urban, moderate Democrats ushered in a period of modernization, reform, and institution building. Brown became speaker in a series of moves so surprising and sudden that enemies called it a coup, and allies jokingly called it the "raid on Entebbe," after the successful Israeli commando action. His authority in the House was such that he was jokingly dubbed "the Hyattola."

Brown served in the Florida House of Representatives from 1972 to 1980 and was speaker of the house from 1978 to 1980. He is shown here in front of his company's old offices—it is now in a five-story building on Ridgewood Avenue—in 1986.

Brown grew up in Daytona Beach, the son of an insurance man, Adrian Brown, of the Brown & Owen Insurance Agency. Soon after he was out of college, he formed Brown & Brown with his father and brother. The offices were downtown, and the company had eight employees. Today, the publicly traded company has 189 offices in 41 states, three overseas offices, and nearly 7,800 employees worldwide.

In February 2015, Daytona Beach saw another side of Brown's many interests when the Cici and Hyatt Brown Museum of Art opened. The museum is home to the Browns' collection of about 2,600 Florida-related artworks. The collection started modestly when the two bought an 1839 watercolor of the gates of St. Augustine in 1997 and soon took off. The couple donated $14.3 million for the 26,000-square-foot building at 352 South Nova Road. (Courtesy of the *Daytona Beach News-Journal*.)

Samuel P. "Sam" Bell III

Sam Bell represented Volusia County in the Florida House of Representatives from 1974 until 1988. He was majority leader when Democrats were the majority party, chairman of the rules committee, and twice chairman of the appropriations committee. He was speaker designate, set to become speaker of the house in 1991, but in an upset election lost his reelection bid in 1988.

Some saw the defeat of such a respected and powerful legislator as a political turning point in state politics and evidence of a coming Republican tilt. Bell is shown here in 1987, negotiating over telephone on the floor of the Florida House.

The Ormond Beach attorney first jumped into area politics helping elect Fred Karl to the Senate and later Hyatt Brown to the Florida House. He was part of the group that drafted Volusia County's home-rule charter and first won election in 1972.

Soon after his 1988 electoral defeat, Bell continued his law practice at Cobb, Cole & Bell but opened a branch office in Tallahassee and moved there. He quickly became one of the capital's preeminent lobbyists. That same year, he married Florida commissioner of education Betty Castor. (Courtesy of the State Archives of Florida.)

Thomas Kent "T.K." Wetherell

T.K. Wetherell was not supposed to become speaker of the Florida House. His friend, supporter, and mentor Sam Bell was. But Bell, who was speaker designate, was defeated for reelection in 1988 by Republican Dick Graham. This created a void that Wetherell—with Bell's help—had to scramble to fill. He had the votes to become speaker in 1991–1992 within two days. He is shown here in 1991 with state senate president Gwen Margolis.

A fifth-generation Floridian, Wetherell graduated from Mainland High School and went to Florida State University on a football scholarship, playing for the Seminoles from 1963 to 1967. He stayed on at FSU to earn a master's degree in 1968 and a doctorate in education administration in 1974.

He came back to Daytona Beach, taught at Bethune-Cookman College, now Bethune-Cookman University, and worked at Daytona Beach Community College, now Daytona State College, leaving in 1990 as vice president for district planning and development.

Wetherell became FSU's 13th president in 2003. During those years, FSU expanded enrollment, started a medical school, and undertook an $800-million building program. In those last years, it has been said that the school's reputation grew even as its budget shrank. He stepped down in 2010. (Photograph by Sam Cranston, courtesy of the *Daytona Beach News-Journal*.)

Edgar M. "Ed" Dunn (1919–2000)

Ed Dunn served in the legislature at a time when Volusia County was at the height of its state influence. He was among Gov. Bob Graham's earliest supporters and was general counsel to Gov. Reubin Askew. He was elected state senator from Ormond Beach in 1974 and served three terms before stepping down in 1986.

Dunn left the Senate to run for state attorney general and narrowly came in first in a four-person Democratic primary before losing to Bob Butterworth by fewer than 1,000 votes in a runoff. He attempted to return to the state senate in 1991 but lost to Sen. Locke Burt by only 227 votes. He is shown here (right) campaigning with Graham (center) that year.

After his political losses, Dunn concentrated on his law practice and community service, donating his legal advice to Enterprise Volusia, helping with the Boy Scouts and the Knights of Columbus, and serving on the Halifax Medical Center board.

A fifth-generation Floridian and son of the pioneer Daytona Beach family that owned Dunn Brothers Hardware for generations, Dunn served on the charter commission that restructured Volusia's county government in the 1970s. During that work, the Daytona Beach Jaycees named him Outstanding Young Man of the Year.

"He is the type of person who allows this country to function, and that's no overstatement," Askew said at Dunn's funeral in 2000. (Photograph by Brian Myrick, courtesy of the *Daytona Beach News-Journal*.)

Dr. Alvin Smith (1931–2007)

Alvin Smith was a son of illiterate sharecroppers. He left school in 10th grade, came back, and did not graduate from Mainland High School until he was almost 21. From that unpromising start, he would become president of the Volusia County Medical Society, and in 1996, the Florida Medical Association. As a leader of the state's doctors, he helped convince Gov. Lawton Chiles to approve an autonomous state department of health and fought the tobacco industry.

After a stint in the Army, Smith became the first college graduate in his family; he earned a biology degree from the University of Florida and a medical degree from the University of Miami. "I didn't do it alone," he recalled. "I had lots of support, assistance and love."

Recalling staring hungrily into the window of the Angell & Phelps candy store on Beach Street, he bought the chocolate factory, a local landmark founded in 1925, when it was for sale in 1983. And he made sure his favorite recipes and even the factory's suppliers stayed the same.

"I was lucky enough to acquire during my boyhood from a step-grandfather . . . a wonderful philosophy of life. It is what I called the 'Auntie Mame' philosophy: The world is a banquet and most of the suckers are starving to death because they won't partake of the feast," he said. He is shown here in a 2007 photograph. (Photograph by Sean McNeil, courtesy of the *Daytona Beach News-Journal*.)

Sophie Kay (1932–2015)

Sophie Kay Petros was already known for television cooking shows in Chicago and Milwaukee when she came here with her son and husband in 1982 and decided to stay. Her restaurant, Sophie Kay's Top of Daytona, atop Peck's Plaza, became a local landmark. In the movie *Days of Thunder* (1990), its distinctive circular dining room can be seen in the scene where the racers keep their sponsors waiting. An outgoing hostess, Petros was known for treating staff and regular customers like extended family. She published 14 cookbooks. (Photograph by Michael Takash, courtesy of the *Daytona Beach News-Journal*.)

Floyd Miles

Bluesman Floyd Miles played with popular soul band the Universals in the 1960s and befriended Gregg and Duane Allman. Gregg once wrote that Miles "taught me how to sing the blues and deeply influenced my phrasing and delivery." His song "Goin' Back to Daytona" is a tribute to the beachside scene of the 1960s. He is shown here singing at the Bandshell in 2006. (Courtesy of the *Daytona Beach News-Journal*.)

Charles Cherry (1928–2004)

City commissioner, activist, entrepreneur, publisher, and radio station owner Charles Cherry was never a man to give up easily. He ran for city commission four times unsuccessfully before winning a seat on the commission in 1995. He would then serve almost five terms before dying in office.

He started *Westside Rapper* in 1969, a free newspaper, and in 1978 founded the *Daytona Times,* a weekly serving the black community. This grew into a full-fledged media company that included another newspaper, the *Florida Courier,* and a number of radio stations including WPUL-AM in Daytona Beach, which provided black-oriented programing for almost 20 years before going off the air in 2014.

Born in Americus, Georgia, Cherry moved here in 1952. In the 1960s, he threw himself into the fight against segregation and became president of the Volusia County–Daytona Beach branch of the NAACP. Later he would become the organization's Florida president and serve on the national board of directors.

He was inducted into the Florida Newspaper Hall of Fame in 2014. (Photograph by Pam Lockeby, courtesy of the *Daytona Beach News-Journal.*)

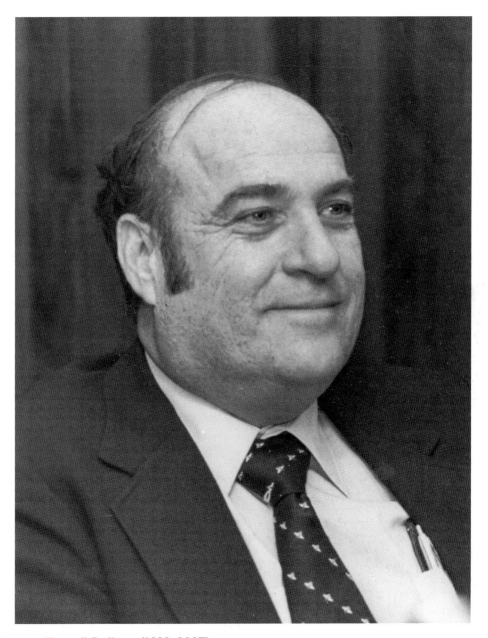

Jerome "Jerry" Doliner (1932–2007)
Jerry Doliner was appointed to the Volusia County Council by Gov. Bob Graham in 1982 and served until 1988. He was particularly interested in economic development and pushed for a tourist-development tax and building of the Ocean Center convention facility. He arrived in Daytona Beach from Brooklyn, New York, in 1944 and worked for his parents' business, running hotel gift shops. He and his wife, Celeste, took over the business in 1960 and owned several beachside gift stores. But Doliner is best remembered as the name on the Jerry Doliner Food Bank, operated by the Jewish Federation of Volusia and Flagler Counties, which feeds thousands. He was a frequent contributor and energetic supporter of the food bank, which was named for him just before his death in 2007. (Courtesy of the *Daytona Beach News-Journal*.)

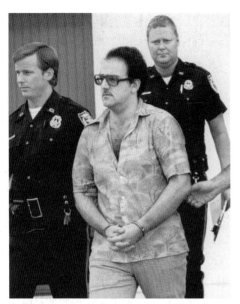

Gerald Stano (1951–1998)
Nobody knows how many people Gerald Stano murdered. He confessed to killing 41 women on the highways of Central Florida before he was executed by electric chair. Stano claimed to have been manipulated into making that claim by Daytona Beach police sergeant Paul Crow, who later became police chief. Stano was subject of the book *I Would Find a Girl Walking* by Diana Montane and Kathy Kelly. He is shown here in front of the Volusia County Courthouse Annex in 1983. (Courtesy of the *Daytona Beach News-Journal*.)

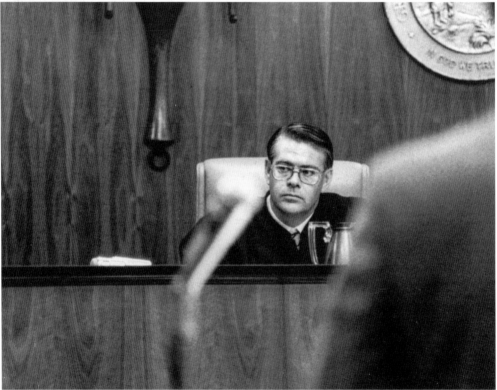

S. James Foxman
James Foxman presided over 20 capital murder cases in his distinguished career. The first one came within weeks of his becoming a judge. Shown here in a 1982 photograph, he sentenced Gerald Stano to death twice in 1983. The S. James Foxman Justice Center was named for him after he retired in 2011. (Photograph by Mark Lane.)

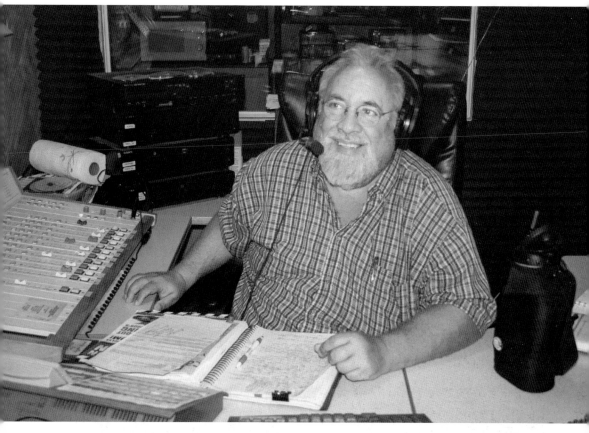

Big John

Yes, Big John is his legal name. Born John Walter Brower in 1945, he came to the Daytona Beach area in 1972 and fell in love with the beach. He became well known locally with his large, bearded image, complete with "Big John" stitched across his shirt's pocket, adorning billboards, newspaper, and television advertisements for Big John's Tire and Muffler. He had his name changed legally in 1979, and that is how it appeared on the ballot for a countywide Volusia County Council seat in 1984. He served until 1992, when he was defeated for a district seat, but was back again six years later and served another term at-large.

Big John found a surprising third career as a broadcaster, where his outspokenness on local issues enlivened drive-time on WELE-AM with the *Big Talk with Big John* show. He came to own the station and in 2015 donated it to Bethune-Cookman University, with the proviso that he continue to speak his mind on the air. (Photograph by Mark Lane.)

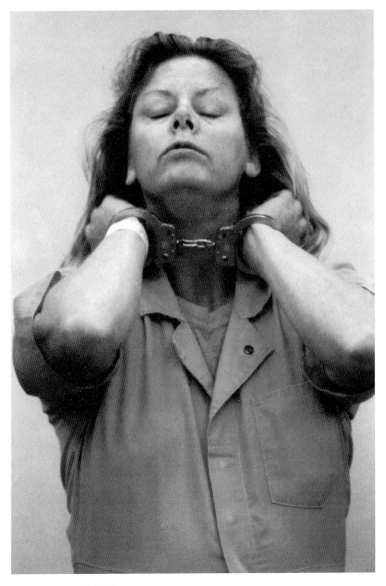

Aileen Wuornos (1956–2002)

Aileen Wuornos, a prostitute convicted of killing six men on Florida roads from 1989 to 1990, was the subject of two movies, an opera, several documentaries, and at least a dozen books. She confessed to a seventh murder, but the body was never found. She was executed by lethal injection in 2002 for the first of those murders, a Clearwater television-repair shop owner who picked her up on Interstate 95 near Ormond Beach in 1989.

"I had to kill them," she said in the one of the several conflicting confessions she made. "It's like I'm thinking, 'You bastards. You were gonna hurt me.' It was self-defense. It was, like, 'Hey, man, I gotta shoot you, 'cause I think you're gonna kill me.' "

Because of her notoriety, the bar where she was arrested in 1991, the Last Resort in Port Orange, is a frequent tourist stop, especially after it was featured prominently in the movie *Monster* (2003). And even the nearby hotel where she lived during the time of the murders finds people asking to stay in or just take a photograph of Room 9. (Courtesy of the *Daytona Beach News-Journal*.)

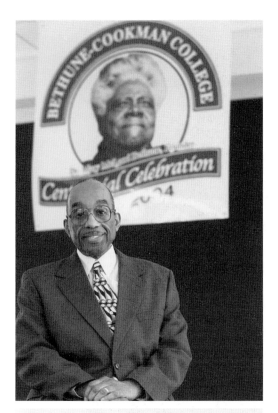

Oswald Perry Bronson

Oswald Bronson was the fourth president of Bethune-Cookman College and oversaw a time of explosive growth. The school's enrollment increased 84 percent, 15 new buildings were constructed, including the 2,500-seat Mary McLeod Bethune Performing Arts Center, 15 major fields of study were added, and its nursing and teacher education programs received full accreditation. While still college president, Bronson was appointed to the Volusia County School Board by Gov. Bob Graham in 1979 and elected to a full term in 1980. (Courtesy of the *Daytona Beach News-Journal.*)

Bruce "Chili" McNorton

Spruce Creek High School graduate Bruce McNorton went to Georgetown College in Kentucky on a football scholarship and emerged as a fourth-round pick by the Detroit Lions in 1982. He built a solid career as a defensive back with the Lions from 1982 to 1990. His popular Bruce McNorton Football Camp in Daytona Beach started as simple football practice with his son. "The next thing we knew, we had about 25 guys out there doing drills with us every day," he said. (Courtesy of the *Daytona Beach News-Journal.*)

Ronald Joseph "Ron" Rice

The Ron Rice story has been told many times. It is a local-boy-hits-it-big story.

It is one of those tales in which a simple idea pays off big. And it has a prop—the trash can. Rice used a 20-gallon trash can to mix a concoction of coconut, avocado, aloe, kukui nut, and other oils in his garage, stirred it with a broomstick, and sold it to the tourists. The rest is marketing history.

On a trip to Hawaii in 1965, Rice, then a teacher and sometimes lifeguard, noticed beachgoers applying coconut oil to their skin. And an idea was born. He came back to Daytona Beach, recruited poolside lifeguards to distribute his product, and demand took off. Tourists brought it home with them, and Hawaiian Tropic started going nationwide. In 1973, Rice opened his Ormond Beach factory and began serious distribution.

In 2007, Playtex bought Hawaiian Tropic for $83 million. Rice (right) is shown with Neil P. DeFeo, CEO of Playtex Products at the Ormond Beach plant when the sale was announced.

Rice had the original garbage can plated with silver in 1990, and it can still be seen at his Ormond Beach home. (Photograph by Jim Tiller, courtesy of the *Daytona Beach News-Journal*.)

Yvonne Scarlett-Golden (1926–2006)

Yvonne Scarlett-Golden was elected the first black mayor of Daytona Beach in 2003 and reelected two years later. A teacher and principal in the San Francisco area, she had retired to her hometown of Daytona Beach and started a new career in public service, first serving as a city commissioner from 1995 to 2003.

Born in Daytona Beach in 1926, she graduated from racially segregated Campbell Senior High School and received her bachelor's degree from Bethune-Cookman College and her master's in education from Boston University. "Who would have thought when I was a little girl that I could grow up to be mayor of Daytona Beach?" she often said.

For 20 years she was principal of San Francisco's Alamo Park Alternative High School (later renamed for Ida B. Wells, 19th-century teacher, suffragette, and advocate for racial equality, a change Scarlett-Golden pushed for). An outspoken community activist in that city, she was charged with inciting a riot in 1974 after demanding that uniformed neo-Nazis be ejected from a board of education meeting. Hundreds rallied in her support. The case was dropped after a mistrial.

As mayor, she is often remembered for her enthusiasm and work to calm the city's special events with the "It's All about Respect" campaign for spring break and black college reunion and her "ride quietly" bike week campaign. She is shown here during black college reunion in March 2001. (City commissioner Darlene Yordon is seen over her shoulder.)

Scarlett-Golden died of cancer while in office in 2006. At her funeral, a noticeably ill Bill France Jr., in his last public speech before he died, spoke of his affection for her: "She was proud to be mayor. That was obvious by the way she ran her meetings and by the way she spoke with authority to 200,000 people before the Daytona 500. She was a good mayor. More importantly, she was a good woman."

In 2013, the city dedicated the $2.5-million Yvonne Scarlett-Golden Cultural and Educational Center in the Derbyshire neighborhood where she grew up. (Photograph by Nigel Cook, courtesy of the *Daytona Beach News-Journal*.)

Vincent Lamont "Vince" Carter Jr.

Even Daytonans who do not follow sports know the name Vince Carter, driving by the Vince Carter Athletic Center at Mainland High School or eating at Vince Carter's restaurant. Then there is Vince Carter's Basketball Academy, the Vince Carter Sanctuary treatment center, and the Vince Carter Embassy of Hope charity.

Born in 1977 at Halifax Medical Center, Carter was a standout at Mainland High School. "Virtually every college coach in the country is interested in Vince Carter's moves," wrote News-Journal sports editor Lydia Hinshaw when he was still a junior. Carter led the school's team to a state championship in 1995 and was named Florida's Mr. Basketball.

Carter was the No. 5 pick in the 1998 NBA draft and the 1999 NBA Rookie of the Year. In 2000, he was part of the gold medal–winning US Olympic men's basketball team. In 2015, his 17th year in the NBA, he played for the Memphis Grizzlies.

He is shown here at his basketball camp in 2012. A statue of him was erected in 2007 next to the Mainland High School gym, which was built with a $2.5 million contribution from Carter. (Above, photograph by David Massey, courtesy of the Daytona Beach News-Journal; below, photograph by Mark Lane.)

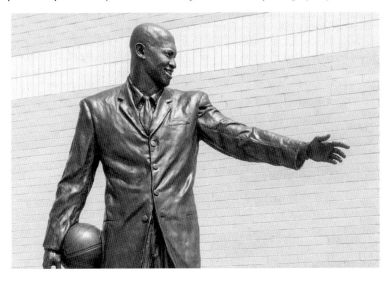

Glenn Ritchey

Before he was a mover and shaker, Glenn Ritchey was just a shaker, playing bass guitar for the Mustangs. Selling cars was supposed to be a day job, and somehow it grew until he owned the place. Now it is Ritchey Cadillac Buick GMC.

Ritchey had the poor timing of becoming mayor just before the economic downturn hit Daytona Beach particularly hard. The city commission appointed him in December 2006 to finish the remaining term of Mayor Yvonne Scarlett-Golden after her death.

People usually heap blame on politicians who happen to serve in bad times, yet Ritchey escaped this. He won a decisive two-thirds of the vote in a crowded primary when he ran for a full term in 2007. He was there to see the Daytona Beach Pier reopen, respond to the 2009 floods, and preside over the openings of the Yvonne Scarlett-Golden Cultural and Education Center, Breakers Oceanfront Park, new police and fire stations, and less noticed but significant, an ambitious citywide road-repaving program. He laid the groundwork for a city revitalization.

In 2015, an ambitious facelift for the Bandshell was begun, and the revitalized area will be named Ritchey Plaza. (Photograph by Mark Lane.)

Lesa France Kennedy

Lesa France Kennedy is part of the current generation of France family oversight of Daytona International Speedway and NASCAR. She is shown here at left with her mother, Betty Jane France, at the Bandshell fundraising for the Ritchey Plaza project in 2015.

She is chief executive officer of the International Speedway Corporation and vice chairwoman of NASCAR. *Forbes* magazine named her the "Most Powerful Woman in Sports" in 2009, and since then her influence has only grown.

In 2007, her husband, plastic surgeon Dr. Bruce Kennedy, died in a private plane crash in Sanford. This happened only a month after her father, Bill France Jr., died.

France is known for having a more collaborative management style—certainly by France-family standards—while pursuing her own vision for expanding racing's fan base and making the race-going experience something even bigger. To that end, she has overseen a $400-million renovation of the speedway and the construction of One Daytona, an entertainment and retail complex across the street from the venue. (Photograph by Mark Lane.)

Ryan Lochte

Ryan Lochte is a star in sport that does not have a lot of stars. But with 11 Olympic medals in swimming to his name, including five gold medals won at three Summer Olympics (in 2004, 2008, and 2012), Lochte has as many Daytona Beach fans as somebody who drives a car for a living.

The famously laidback Lochte has been featured on covers of *Vogue*, *Men's Health*, and *Time* and starred in a reality show *What Would Ryan Lochte Do?* that lasted one season in 2013. He has earned an estimated $2.3 million from endorsement deals and has more than one million Twitter followers.

Lochte came to the area from New York when he was 11, and his father, Steve Lochte, became the aquatics director for the Port Orange YMCA. His father recalls Ryan first being in a pool when he was two. Lochte graduated from Spruce Creek High School in 2002 and the University of Florida in 2006. He is shown here in the Port Orange YMCA pool in 2001. (Courtesy of the *Daytona Beach News-Journal*.)

Cubby T. Bear (1994–2014)
The Chicago Cubs minor-league team, the Daytona Cubs, started playing in Jackie Robinson Ballpark in 1993. During the team's second season, it unveiled a teddy bear–like mascot, Cubby, shown here in 2011 with an unidentified associate. He became a beloved ballpark fixture as the team went on to take six Florida State League championships. Sadly, when the Cubs moved to Myrtle Beach, South Carolina, after the 2014 season, the team was renamed the Myrtle Beach Pelicans, and Cubby was cut from the roster. He is reportedly in storage. (Photograph by Cindi Lane.)

Bryan Cranston
Bryan Cranston, who garnered popular and critical acclaim in his role as Walter White, a high school chemistry teacher-turned-methamphetamine-brewing drug kingpin on *Breaking Bad*, had some of his earliest roles in community theater in Daytona Beach. His parents, Peggy and Joseph Cranston, managed a small motel on Atlantic Avenue. Starting with a 1978 Daytona Playhouse production of *The King and I*, he went on to sing and dance through the second season of Summer Music Theater. He left town on a used motorcycle to make it big in Hollywood, and unlike most stories that begin that way, he actually did. (Courtesy of the *Daytona Beach News-Journal*.)

BIBLIOGRAPHY

Booth, Fred. *Early Days in Daytona Beach, Florida: How a City Was Founded.* Daytona Beach, FL: Halifax Historical Society, 1951.

Fitzgerald. T.E. *Volusia County, Past and Present.* Daytona Beach, FL: The Observer Press, 1937.

Gold, Pleasant Daniel. *History of Volusia County, Florida.* DeLand, FL: Painter Print Co., 1927.

Hawks, Milton. *The East Coast of Florida.* Lynn, MA: Lewis & Winsship, 1887.

Hawks, Esther Hill, and Gerald Schwartz. *A Woman Doctor's Civil War: Esther Hill Hawks' Diary.* Columbia, SC: University of South Carolina Press, 1984.

Hebel, Ianthe Bond. *Centennial History of Volusia County, Florida, 1854–1954.* Daytona Beach, FL: College Publishing Co., 1955.

Hurston, Zora Neale. *Zora Neale Hurston: A Life in Letters.* New York, NY: Doubleday, 2002.

Lamb, Chris. *Blackout: The Untold Story of Jackie Robinson's First Spring Training.* Lincoln, NE: University of Nebraska Press, 2004.

Lane, Mark. *Sandspurs: Notes from a Coastal Columnist.* Gainesville, FL: University Press of Florida, 2008.

Lempel, Leonard R. "The Mayor's 'Henchmen and Henchwomen, Both White and Colored:' Edward H. Armstrong and the Politics of Race in Daytona Beach, 1900–1940." *Florida Historical Quarterly* 79, No. 3 (Winter 2001).

Schene, Michael G. *Hopes, Dreams, and Promises: A History of Volusia County, Florida.* Daytona Beach, FL: News-Journal Corp., 1976.

Strickland, Alice. *The Valiant Pioneers: A History of Ormond Beach.* Ormond Beach, FL: Ormond Beach Historical Society, 1963.

Torrey, Bradford. *A Florida Sketch-book.* Boston, MA: Houghton Mifflin Co., 1924.

INDEX

AN IMPRINT OF ARCADIA PUBLISHING

Find more books like this at
www.legendarylocals.com

Discover more local and regional history books at
www.arcadiapublishing.com

Consistent with our mission to preserve history on a local level, this book was printed in South Carolina on American-made paper and manufactured entirely in the United States. Products carrying the accredited Forest Stewardship Council (FSC) label are printed on 100 percent FSC-certified paper.

MADE IN THE
USA